MICHAEL WESELY
OPEN SHUTTER

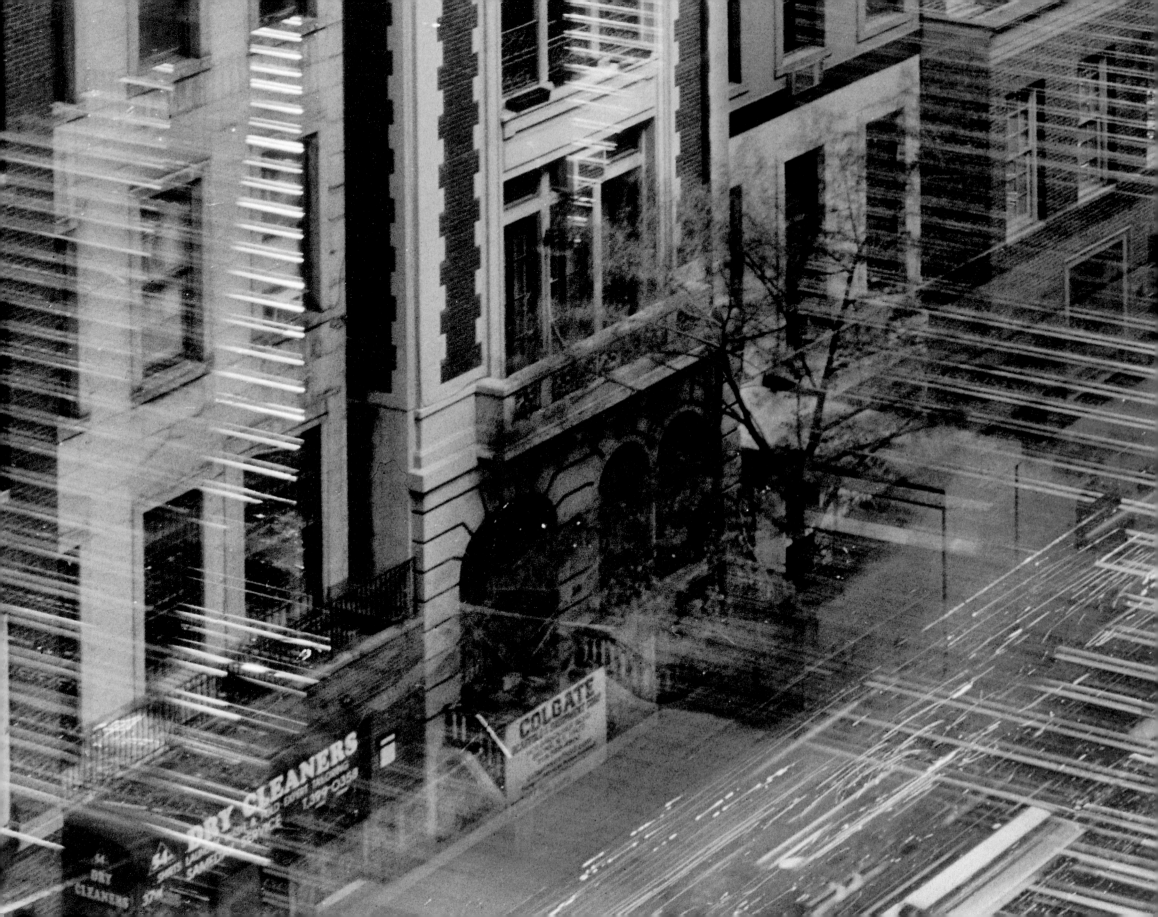

MICHAEL WESELY
OPEN SHUTTER

SARAH HERMANSON MEISTER

THE MUSEUM OF MODERN ART, NEW YORK

Published on the occasion of the opening of the new Museum and the exhibition
Open Shutter, organized by Sarah Hermanson Meister, Associate Curator, Department
of Photography, The Museum of Modern Art, New York, November 20, 2004.

Produced by the Department of Publications
The Museum of Modern Art, New York

Edited by Cassandra Heliczer
Designed by Naomi Mizusaki, Supermarket, New York
Production by Marc Sapir
Typeset in Alternate Gothic and Franklin Gothic
Printed and bound by Trifolio S.R.L., Verona, on 170 gsm PhoenixMotion Xenon

Library of Congress Control Number: 2004110674
ISBN: 0-87070-682-9

Published by The Museum of Modern Art
11 West 53 Street
New York, New York 10019-5497
(www.moma.org)

Distributed in the United States and Canada by D.A.P./Distributed Art Publishers, Inc., New York

Distributed outside the United States and Canada by Thames & Hudson, Ltd., London

Cover: Michael Wesely. Details of *9.8.2001–7.6.2004 The Museum of Modern Art,
New York.* See page 39

Frontispiece: Michael Wesely. Detail of *9.8.2001–2.5.2003 The Museum of Modern Art,
New York.* See page 35

Printed in Italy

FOREWORD

Since it was founded seventy-five years ago, The Museum of Modern Art has never ceased to grow and evolve, and the history of its building projects in the heart of a thriving city is long and complex. Led by the vision and extraordinary generosity of David Rockefeller and its Board of Trustees, the Museum is now concluding the most ambitious of those projects to date. Architect Yoshio Taniguchi has brilliantly resolved the challenge of expanding and reshaping the Museum's home in a way that at once honors its past and propels its unfinished experiment into the future.

Together with Mary Lea Bandy, Deputy Director for Curatorial Affairs, I was eager to pursue creative ways of documenting and celebrating the evolution and ultimate realization of Taniguchi's great achievement. In 1998, as the design was taking shape, the Museum acquired an unusual photograph—a yearlong exposure made in the office of the director of the Lenbachhaus, in Munich. I got to know the picture as it hung for some months in the vestibule of my office, and soon I got to know Michael Wesely, the thoughtful and inventive young German artist who had made it. In the meantime, Wesely had embarked on a far more ambitious initiative at Potsdamer Platz, in Berlin; some of his photographs of that huge construction site were exposed for as long as twenty-six months.

My colleagues and I recognized our good fortune. Just as the actual construction of Taniguchi's design was about to begin, Wesely's unique art of recording major projects of urban architecture had reached a splendid maturity. In the spring of 2000, Wesely kindly accepted our invitation to apply his art to the Museum's then rapidly unfolding project. Under the guidance of Mary Lea Bandy and Peter Galassi, Chief Curator of Photography, Sarah Hermanson Meister, Associate Curator in Photography, took on what turned out to be a daunting logistical task. I thank her for the skill with which she mastered that task, and for her thoughtful presentation in this book of the ultimate—and remarkable—results.

Working closely with Sarah Meister, Wesely chose four locations for his cameras. One was within an existing Museum building. But the other three required the generous cooperation of the owners and managers of nearby buildings, who were asked to allow Wesely to attach his bulky cameras to their structures for a period of nearly three years. Thus, I am pleased to extend the full measure of the Museum's gratitude to the following individuals and institutions: at The University Club, K. Jeffries Sydness, the current President, Jerome P. Coleman, President when the cameras were installed, and John P. Dorman, General Manager; at Reckson Associates Realty Corporation, Philip Waterman III, Executive Vice President, Chief Development Officer, and Managing Director, New York City, and Kevin Odell, Building Manager, 1350 Avenue of the Americas; at the City Athletic Club, Michael Todres, President, and Michael Gyure, General Manager. Finally, I join the leadership of The University Club in thanking the New York City Landmarks Preservation Commission, which kindly granted Wesely permission to mount his cameras to the landmark building.

Every artist knows that the excitement of beginning a new work or project comes with anxiety about how it will end. Generally speaking, however, the longer the course of the project, the more opportunity there is for the artist to reconsider and revise. In his project for the Museum, Wesely was denied that comfort. Careful as his preparations were, he had no choice but to set up his cameras and wait—for nearly three years. I am deeply grateful to Wesely for taking on the challenge, and, of course, for the extraordinary and fascinating pictures he has made to celebrate the new Museum of Modern Art.

Glenn D. Lowry
Director, The Museum of Modern Art

ACKNOWLEDGMENTS

From the outset, Glenn D. Lowry, Director, and Mary Lea Bandy, Deputy Director for Curatorial Affairs, have been steadfast in their support of Michael Wesely's project for The Museum of Modern Art, despite their knowledge that the outcome was unpredictable. Peter Galassi, Chief Curator, Department of Photography, has guided many aspects of *Open Shutter* with patience and insight, and the project could not have come to fruition without his involvement. I would also like to thank Susan Kismaric, Curator in Photography, for her thoughtful comments on the essay.

Many individuals lent their cooperation, and I thank them and the institutions they represent for enabling us to mount Michael Wesely's cameras to their buildings. Tim Lynch, structural engineer at Robert Sillman Associates, went out of his way to help Wesely adapt his plans to particular challenges as they arose. At the Museum, Negar Ahkami, Amy McLaughlin, Laura Santaniello, and Rachel Crognale expertly managed countless bureaucratic details and kept the project on track.

Open Shutter is accompanied by this book, thanks largely to three people: Marc Sapir, Production Director, ensured that the quality of the reproductions did justice to Wesely's photographs; Cassandra Heliczer, Associate Editor, edited the text with characteristic grace; and Naomi Mizusaki created the elegant design. I am grateful for their contribution. In addition, I thank Michael P. Maegraith, Publisher. This publication could not have been produced without his commitment and support.

My final and deepest thanks are to Michael Wesely, whose talent and creativity are matched by his unfailing enthusiasm and good humor. It has been a great privilege to know and work with him.

Sarah Hermanson Meister
Associate Curator, Research and Collections
Department of Photography

OPEN SHUTTER

SARAH HERMANSON MEISTER

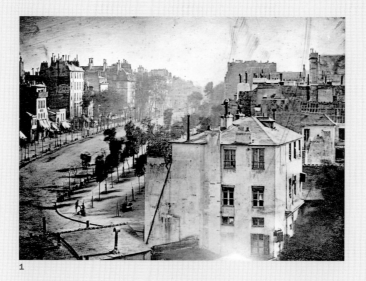

1

Photographs are made by exposure to light, and that exposure takes time, even if it is very short—in many cases only hundredths of a second. For Michael Wesely's photographs, the time is very long—sometimes as long as three years. Exposures of this length are unprecedented in the history of photography, and they allow us to experience the passage of time in an unfamiliar, challenging, and rewarding way.

In the spring of 2000, The Museum of Modern Art invited Wesely to respond to Yoshio Taniguchi's design for its renovation and expansion, taking advantage of the unique opportunity to capture this turning point in the Museum's history. For nearly three years leading up to the Museum's seventy-fifth anniversary, Wesely's cameras were trained upon the realization of Taniguchi's design, recording the emergence of a new museum within its immediate urban environment.

It takes patience and close attention to read Wesely's long exposures, and that is part of their meaning. In midtown New York, tourists and taxis are a constant presence, yet their movements were too fleeting to be recorded. Every day, the construction workers ate lunch in front of Wesely's cameras, but they are nowhere to be seen. The surrounding buildings appear as solid forms, but only because the face they presented daily to the cameras was unchanged. Most of the structures that were demolished or built during the exposure have a ghostlike presence, evoking simultaneously a vanishing and an emerging vista.

One of photography's biggest challenges in its earliest days was capturing motion. In 1839, the year that Louis Jacques Mandé Daguerre's invention was made public, one observer noted, "The impression of the image takes place with greater or less rapidity, according to the intensity of the light [.... Even] in the most favorable circumstances, [Daguerre's photographs] have always been too slow to obtain complete results, except on still or inanimate nature. Motion escapes him, or leaves only vague and uncertain traces."[1] Indeed, an early daguerreotype taken from the inventor's own window displays what seems at first to be a tree-lined but otherwise empty boulevard and sidewalk, void of its population. A closer look at the lower left-hand corner, however, reveals what is perhaps the first person ever captured in a photograph—a man getting his boots shined stood still long enough to appear in the image.

Nearly four decades later, Eadweard Muybridge famously succeeded in recording a galloping horse in arrested motion, and exposures short enough to freeze movement soon became standard. For well over a century, we have taken it for granted that photographs stop time. The challenge of looking at Michael Wesely's pictures is to unlearn that habit.

Wesely first experimented with long-term exposures in 1988, while he was a student at the Bavarian State School for Photography, in Munich. Faced with a portrait assignment, he was not convinced that the essence of a person could be captured in a fraction of a second, and by his own account he was an unexceptional portrait photographer. His solution was as simple as it is radical: "I just turned this system upside down and said, 'Okay, I cannot collect the best moments, or cannot find them in my contact sheets, so I'd better collect millions of moments in one picture.'"[2] Wesely's response to his assignment was in part a reaction against the pervasive notion, articulated by the French photographer Henri Cartier-Bresson in *The Decisive Moment* (1952),

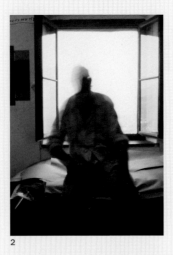

2 3

2. Michael Wesely. *8 min. Emilio Vedova.*
 1988. From the series Pinhole Camera
 Portraits (Lochkamera Portraits).
 Gelatin silver print, 23 ⅝ x 19 ¹¹/₁₆ in.
 (60 x 50 cm). Collection Michael Wesely

3. Michael Wesely. *20 min. Johanna
 Hess-Dahm.* 1988. From the series
 Pinhole Camera Portraits (Lochkamera
 Portraits). Gelatin silver print, 23 ⅝ x
 18 ⅛ in. (60 x 46 cm). Collection
 Michael Wesely

4. Michael Wesely. *Hamburg 9:07–
 Munich 18:06.* 1992. From the series
 Travel Time (Reisezeit). Gelatin silver
 print, 36 ¼ x 48 ¹/₁₆ in. (92 x 122 cm).
 Collection Städtische Galerie im
 Lenbachhaus, Munich

that within every scene unfolding before the camera there exists a single, essential moment, and that the photographer's job is to seize it.[3] Wesely wondered whether a longer exposure might not convey more about the subject than a single moment plucked from life by the photographer, and he intuited that, by having his subjects compose themselves over an extended period of time, he was inviting the possibility of a more complete likeness—one that would reveal not just what his subject looked like, but what it would have been like to be in his or her presence.

Wesely's titles for his portraits note the length of the exposure, suggesting that the pictures are as much about time as about the sitter. During an eight-minute portrait, for example, the painter Emilio Vedova moved sufficiently from his original position that the light from the window behind him erased parts of his head and shoulders, and his dramatic gesticulation allowed the window frame to become visible through his right arm. Yet these departures from conventional description are impartial records of what transpired before the camera. What might be considered flaws are in fact an unfamiliar kind of evidence.

To understand that evidence, it may be helpful to consider that Wesely's pictures, like most photographs, are positives printed from negatives. At any given point in the image, the stronger the light, the denser (darker) the negative will be once it is developed. The values are reversed in the positive print. A significant consequence of the process for Wesely's long exposures is that, once a given area of the negative has reached maximum density by exposure to strong light, the corresponding area in the positive print will be white. This is why the bright light from the window erased parts of Vedova's head and

shoulders. But the effect is not reciprocal. Once a bright area has fully registered its presence, no dark object placed in front of it can appear, no matter how long it remains in position. On the other hand, even a relatively brief incident of strong illumination will leave its mark in an area that remained dark for the majority of the exposure.

In the pinhole cameras that Wesely built to make his portraits, the image is formed by light passing through a tiny hole—literally, a pinprick. Because the aperture is so small, the amount of light is much less than a conventional lens would provide, and the required exposure is correspondingly longer. Even so, in order to extend his exposure times, Wesely found that he needed to work under circumstances where the light level was low—indoors, or early in the morning. The light was so weak for his portrait of artist Johanna Hess-Dahm that Wesely had to extend the exposure to twenty minutes. After fifteen minutes, Hess-Dahm removed her jacket because the room was warm. In the resulting photograph both the jacket and the sleeve of her T-shirt beneath it are visible, and this was a revelation for Wesely: "That was the moment when I realized that extended exposure time as a rule can be used as something to tell a story." He recognized, in other words, that to decipher his long exposures, the viewer would have to imagine a narrative to explain their sometimes strange but nonetheless factual accumulation of clues.

By 1992, as Wesely's titles reveal, he had begun measuring his exposures in hours rather than minutes. He was now using a commercially available large-format camera, fitted with a true lens that yielded a sharper image—a standard piece of equipment. But his experience with the pinhole portraits had led him to think of his exposures in a way that was anything but standard. For most

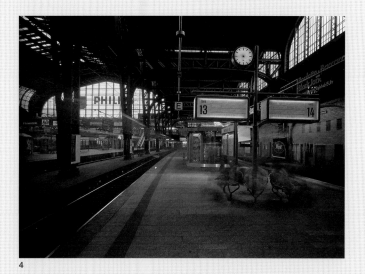

4

photographers, the exposure time is a merely technical matter—generally long enough to register the image and short enough (usually less than one-thirtieth of a second) to stop motion. By contrast, Wesely adopted the exposure time as the essential conceptual framework of his pictures. Henceforth, the length of the exposure would be dictated by the duration of an action or event.

For his 1992 series Travel Time, for instance, Wesely set up his camera on train platforms around Europe and began the exposure the moment the train left the station. Each exposure was to last as long as it took the departed train to reach Munich, Wesely's birthplace and home at the time. In effect, he was photographing train journeys without ever leaving the station. Each picture is a document of a trip through time in a fixed space (the station) and a metaphor for the train's actual journey through another space (the route to Wesely's Munich home).

That same year, Wesely expanded the Time Travel series by reversing its terms. Instead of visiting many stations and tracking trains bound for Munich, he worked in Prague's Central Station and timed his exposures to match the schedules of trains en route to destinations throughout Europe. Czechoslovakia had recently become open to the West, and Wesely viewed these outward journeys from Prague as a fitting symbol of a new political reality. The nominal subjects of the pictures—the trains themselves—are invisible, since they stood in the station for just the first few moments of each exposure. Certain fixed elements appear with perfect clarity: the tracks, the platforms, the intricate ironwork of the roofs, the signage. But the clocks have no hands, and the stations seem eerily quiet, devoid of the crowds that typically teem through them. Only close study will reveal the ghostlike

figures clustered around benches and kiosks, where people remained still long enough to be registered.

Wesely's longest exposure for the Travel Time series lasted about two days, but curiosity led him to attempt ever-longer ones: "After the longest train station picture, I was always doubling the time: one week, two weeks, four weeks, because I was thinking that at a certain point the exposure would just stop, that the plate wouldn't register any more, that it didn't have the sensitivity to collect more light." To his amazement, the negatives continued to record change, even when used for exposures that were hundreds of thousands of times longer than the negatives had been designed to capture. His essential tool for slowing down the exposure was a very dense filter. But the usual rules for calculating the correct exposure no longer applied. Old-fashioned trial and error was required.

"I was working with these longer extended exposure times, and then I thought to myself, 'Why not? Three months, four months is not really a significant time frame from my perspective.' I thought, 'At least I have to get a one-year picture, because everyone knows about the value of one year—celebrating everything, birthdays, jubilees, or whatever.' So the one-year exposure became my target." By 1994, Wesely felt confident that he could reach it. Helmut Friedel, then director of Munich's Städtische Galerie im Lenbachhaus, had been following Wesely's work for years, and he agreed to let the artist set up two cameras: one in Friedel's office, the other in the galleries. At the end of the year, Wesely developed the negatives and discovered that the cameras had shifted—only slightly, but enough to ruin the images. Undaunted, he was encouraged by the fact that the exposures themselves were correct. "I was somewhat

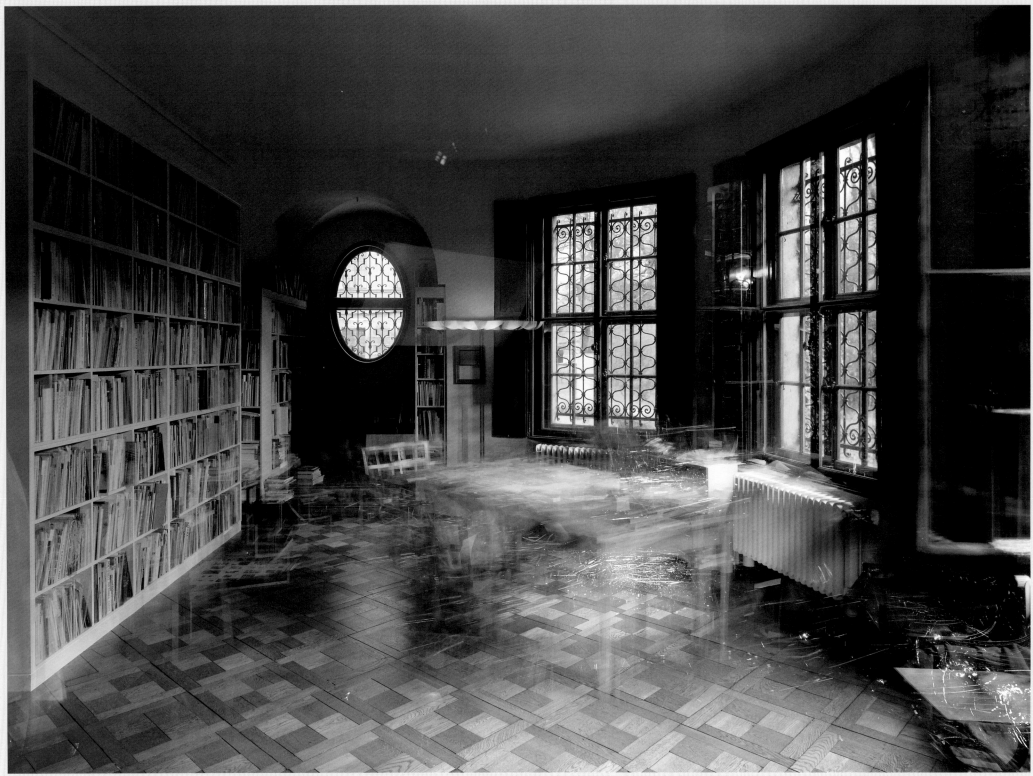

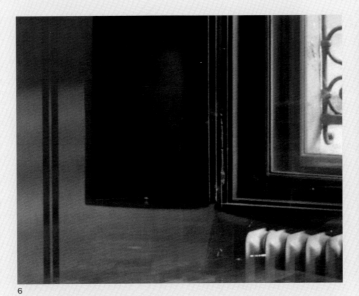

6

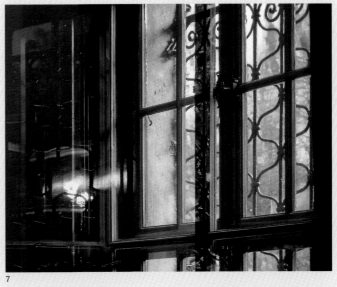

7

5. Michael Wesely. *29.7.1996–29.7.1997*
Office of Helmut Friedel. 1996–97.
Gelatin silver print, 16 9/16 x 23 in.
(42.1 x 58.5 cm). The Museum of
Modern Art, New York. Gift of Susan G.
Jacoby in memory of Edward Goldberger

6–7. Details of *29.7.1996–29.7.1997*
Office of Helmut Friedel

shocked that the cameras had moved, and I had to think about what was really necessary—and what wasn't. These cameras were expensive, and they were built for the changing focus and all sorts of things I did not need for my long exposures. So I thought, 'I know how to build pinhole cameras, so in the same way I can also build my own large-format cameras.'" In February 1995, Wesely was invited to set up durable cameras that he had designed and built, secured to heavy metal tripods that were virtually impossible to move accidentally, in the Portikus gallery in Frankfurt am Main and in the office of Kasper König, its director. Twelve months later, he completed his first successful one-year photographs.

In July 1996, Wesely returned to the Lenbachhaus and repeated his success. The view of Friedel's office is structured by its architecture. The bookcase defines the left edge, while the line along the curve of the exterior wall connecting the upper frames of the windows leads to the top right-hand corner of the picture. Wesely has always conceived of his photography in relation to architecture: "The framework is an architectural view, but it's only the frame. Time itself is the subject, manifesting itself in many details. The details are the essential things that tell the story, and for that reason it is important to look closely."

Traces of human activity are readily apparent. The blurred outline of Friedel's desk and the papers upon it denote their subtle shifting over the course of the year. Glinting reflections from the tubular steel of the director's chair indicate its countless accidental positions. But not all traces are cumulative in this way. One day, for example, a television crew visited Friedel's office to conduct an interview with him. Although the interview lasted for only a few of the nearly

nine thousand hours spanned by Wesely's exposure, the rectangular screen diffusing the television light was so bright that it is clearly evident in the image. The strong light fixed the pole of Friedel's floor lamp in a single position, although the horizontal drift of its illuminated bowl shows that the lamp occupied many positions over the year. As it happened, Friedel sat for the interview in front of a dark window shutter. The serendipitous combination of the strong illumination and the dark background rendered his head and shoulders visible—but just barely (see figure 6). This is Friedel's one appearance, despite all the time he spent in his office that year. More commonly, Friedel's absence meant that objects would remain long enough in one place to register, as seems to be the case with an uncut page proof on the floor before the bookcases, and a coat draped over a chair in the lower right-hand corner. One more detail deserves notice: on what was likely a hot summer night (or perhaps several nights), an office window was left open at an angle that reflected a nearby streetlight (see figure 7). Again, a dark shutter provided the perfect background for the reflection. Wesely, of course, can neither anticipate nor control such effects, but he delights in the rewards that they offer an attentive viewer.

In 1996 Wesely also decided to use his extended exposures to capture the city of Berlin during a period of dramatic transformation, and in the spring of 1997 he set up five cameras around Potsdamer Platz, the largest construction site in Europe at the time. The results were his longest exposures to date, some as long as twenty-six months. Once the bustling center of Berlin, Potsdamer Platz had been destroyed by Allied bombing near the end of World War II. Situated at the dividing line between East and West, it had remained an all but empty wasteland for nearly half a century.

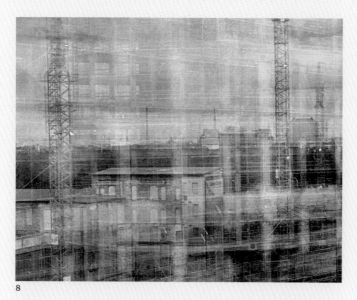

8

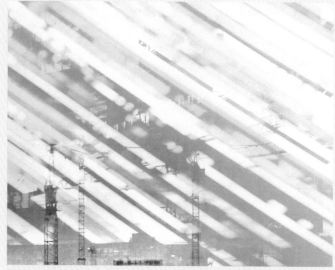

9

8. Detail of *4.4.1997–4.6.1999
Potsdamer Platz, Berlin.* See page 55

9. Detail of *5.4.1997–3.6.1999
Potsdamer Platz, Berlin.* See page 59

Now, a massive building scheme was reshaping the site. In one of Wesely's pictures, the Brandenburg Gate and the dome of the Reichstag under construction—two of Berlin's most famous monuments—can be seen on the horizon, through the translucent armature of the new buildings rising in the foreground (see figure 8). Never again will these monuments be visible from this perspective. Literally superimposing the new upon the old, Wesely's photograph creates a unique representation of Berlin's historical transformation.

One of the most surprising and beautiful effects in the Potsdamer Platz photographs—and in a number of Wesely's subsequent urban exposures—is the rendering of the sun. And, once we learn to read it, the beauty is full of meaning. Although we know very well that the earth orbits the sun, from our terrestrial perspective the sun appears to move, rising and setting each day and shifting laterally across the sky over the course of a season. Wesely's pictures render these passages as a dense series of parallel arcs, interrupted here and there by patches of bad weather.

In one image, the full scope of the sun's positions in the sky is visible (see page 59). At the left, the sun traces its path on the winter solstice, the shortest day of the year in the northern hemisphere, when the sun is lowest in the sky. In the upper right-hand corner, we see a fraction of the sun's passage during the summer solstice. The gray gaps in the white arcs represent cloudy periods of time (see figure 9). Since the exposure lasted more than two years, and since a single sunny day was enough to create an unbroken streak of white in a given arc, the gaps in fact represent the uncanny coincidence of cloudy periods on particular days that were months apart. For a single gap to appear in an arc, for example, the sun would have had to be obscured on a given day in,

say, October, and then again on the day in February when the earth was in the same position with respect to the sun, and then again the following October, and once again the following February.

+++

Wesely has given the title *Open Shutter* to his project for The Museum of Modern Art. But of course he has no need of a shutter—the mechanical device that enables stop-action photography by trimming the time of exposure to fractions of a second. Like Daguerre and all other photographers of the mid-nineteenth century, all Wesely needs is a way of covering and uncovering his lens.

Open Shutter continues the artist's ongoing investigation of the structure and fabric of urban change through long-term exposures. Here Wesely applied methods he had invented for the Potsdamer Platz series—techniques for keeping his cameras immovably fixed for a long period of time, and for protecting them from heat, cold, and precipitation. The project involved a considerable amount of forethought and labor, not just at the beginning but throughout the period of exposure—during which Wesely was obliged to check on his cameras from time to time and to wipe away the city grime from the glass protecting the lenses. Even so, the weather left its mark on one picture, made by a camera whose perspective often faced the sun (see page 39). The light of the sun, refracted through droplets of water on the protective glass, created in the image a scattered array of hexagonal forms (derived from the shape of the aperture of Wesely's lens).

Working from the baseline of his successful multiyear pictures at Potsdamer Platz, Wesely estimated his exposures by taking into account both New York's latitude relative to Berlin's and the relative frequency of cloudy and sunny days. But the central challenge was the same—to decide upon the best available locations for his cameras and then to negotiate the rights to put them there for an extended period of time. He found one suitable spot within the Museum itself, but the other three required the cooperation of the owners of other buildings.

The Museum campus occupies the middle of the block between West 53rd and 54th Streets and Fifth and Sixth Avenues. To the south, along 53rd Street, Taniguchi elected to preserve the facades of three contiguous Museum buildings. From east to west, they are the East Wing, designed by Philip Johnson and completed in 1964; the Museum's first permanent home at 11 West 53rd Street, designed by Philip Goodwin and Edward Durell Stone, and completed in 1939; and the fifty-four-story residential tower (the first seven floors of which are incorporated into the Museum), designed by Cesar Pelli and completed in 1984. Concluding the sequence at the west is the facade of Taniguchi's new gallery complex, topped by an eight-floor office tower.[4]

To the north, along 54th Street, Taniguchi projected a much more dramatic transformation, and Wesely consequently chose to focus his attention there. Between June and August 2001, he installed cameras at four locations (see map, following page):

1. Within the Goodwin-Stone building on the third floor, looking east and slightly north toward 54th Street through the glass enclosure of Pelli's Garden Hall.

2. On the eastern terrace of the City Athletic Club, at 50 West 54th Street, looking east and slightly north.

3. At 1350 Avenue of the Americas, toward the western end of the block, looking east and slightly south across 54th Street toward the Museum site.

4. On the balcony of The University Club, at the eastern end of the block, looking west and slightly south across 54th Street toward the Museum site.

At each location were two cameras: one for black and white, and one for color—an experiment for Wesely, who until then had used only black and white for exposures of this length.

The best-laid plans sometimes go awry. Preparing for the demolition of the Garden Hall in February 2003, the construction crew took down the two cameras that had been installed in the Goodwin-Stone building, fearing for the cameras' safety (location 1 on map; and page 33). After only eighteen months, the color transparency was underexposed, but the black-and-white plate yielded an image. Although the Garden Hall would be dismantled in April, little had changed during the exposure. Nevertheless, a faint trace of the 1929 Ludwig Mies van der Rohe Barcelona chairs and the shadowy outline of Alberto Giacometti's 1930–32 sculpture *Figure in a Garden* hint at the final exhibitions before the Museum moved to its temporary quarters in Queens.

In May 2003, Wesely was obliged to remove the cameras mounted to the City Athletic Club, because the building was scheduled to

10. Map showing the locations and
approximate scope of Michael
Wesely's cameras for *Open Shutter*.
The major elements of the Museum's
campus can be summarized as follows:

A. David and Peggy Rockefeller Gallery
 Building (completed in 2004, designed
 by Yoshio Taniguchi).

B. Residential Museum Tower (built as part
 of the expansion project in 1984,
 designed by Cesar Pelli & Associates;
 facade extended by Taniguchi in 2004 to
 make it a more integral part of MoMA's
 campus).

C. Jo Carole and Ronald S. Lauder Building.
 (Designed by Philip L. Goodwin and
 Edward Durrell Stone, and completed in
 1939, this International Style building
 was restored and renovated by Taniguchi
 in 2004.)

D. East Wing (opened as part of expansion
 in 1964, designed by Philip L. Johnson,
 restored and renovated by Taniguchi
 in 2004).

E. Lewis B. and Dorothy Cullman Education
 and Research Building (projected com-
 pletion 2005–06, designed by
 Taniguchi).

F. Abby Aldrich Rockefeller Sculpture
 Garden (designed by Philip L. Johnson
 in 1952–53, restored and renovated
 by Taniguchi in 2004).

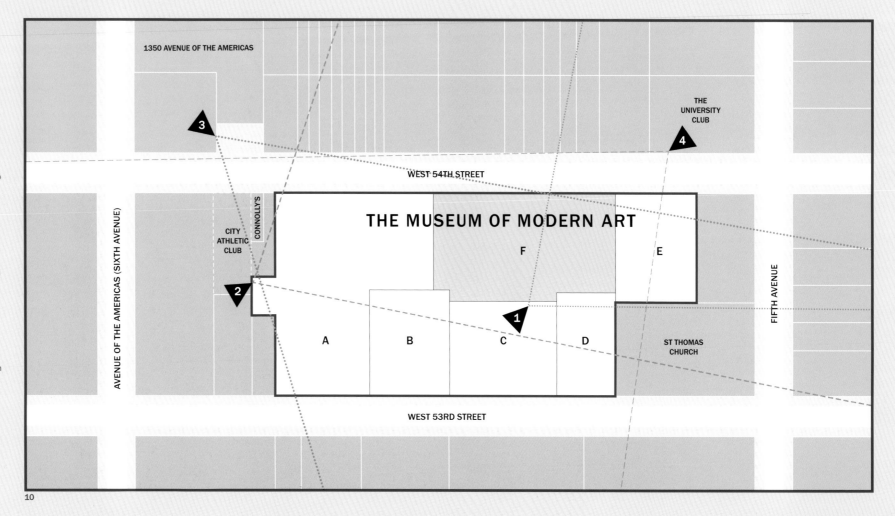

10

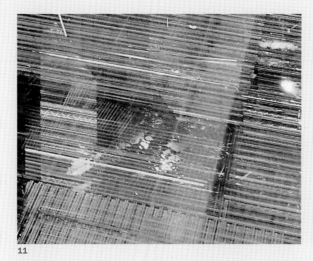

11

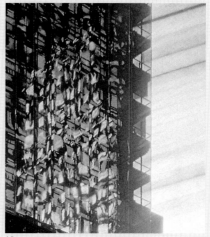

12

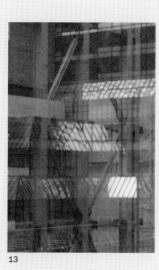

13

be demolished (location 2 on map; and page 35). In fact, the exposures had effectively concluded in September 2002, when the fire-stair of Taniguchi's new building rose to block the cameras' view. Once again, the color image was underexposed, but the black-and-white image was a success; it offers a vivid record of the emergence of the new building, whose structure was already in place by the time the fire-stair wall was erected.

Extending across the full width of the image are the rising layers of steel decking, gleaming in the sun. On one floor the light is vividly reflected in a puddle, apparently formed after the concrete had been poured over the steel, since the surface of the water does not seem to be affected by the corrugation of the decking (see figure 11). The upper left-hand portion of the image registers the foreground silhouette of the temporary construction hoist platforms as a pattern of crisscrossing shadows above The Sherry Netherland Hotel. Along the north side of West 54th Street, splinters of reflected light from the chrome trim of parked cars form clusters at regular intervals dictated by the parking meters (see pages 36–37).

The pairs of cameras across 54th Street at either end of the block remained in place, as planned, until June 2004—the scheduled date for the completion of major work on the construction project. These cameras yielded three photographs, two in black and white, one in color, each of which expresses different facets of the development of a very complex process (locations 3 and 4 on map; and pages 39, 43, and 47). Snapshots by Wesely from both locations at the beginning and end of the exposures can help us to interpret the results.

On this side of the site, Taniguchi framed the Museum's expanded campus with two giant porticoes, which face each other across the Abby Aldrich Rockefeller Sculpture Garden. He further unified the whole by replacing the northern facades of the Johnson and Goodwin-Stone buildings with a delicate curtain wall of fritted glass. To accomplish this, the steplike structure of the Garden Hall was removed, and at its western end the northeast corner of the Pelli tower was extended downward from the seventh floor to ground level in the garden.

Wesely's long exposures do not describe this elegant design. Instead, they reflect the gritty complexity of the construction process that brought it into being. At the center of a snapshot by Wesely from the west end of the block (see figure 14a), made in the summer of 2001, is the empty site formerly occupied by the Dorset Hotel, flanked on the east by the Museum's former North Wing (demolished shortly thereafter) and on the west by a townhouse whose ground floor is occupied by Connolly's restaurant (whose sign would change design and position a number of times over the next three years). Further to the west—anchoring the right edge of Wesely's long exposure from this location—is the City Athletic Club. The club stood for almost the full first two years of Wesely's exposure, and so presents what seems to be a solid and stable structure. But after it was demolished in June 2003, the rough exterior wall of the abutting townhouse registered its presence at the ground-floor level (see page 41).

Wesely's before-and-after snapshots were taken in summer, when the trees along the north side of West 54th Street were in full foliage. In the extended exposure, the trees are simplified to their leafless structures, silhouetted against the cacophony of lights on

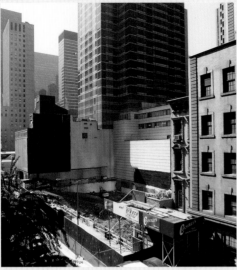 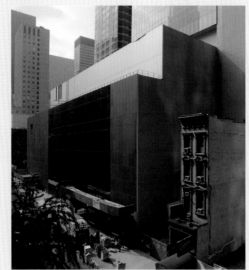

14a 14b

the street (see page 40). From this vantage point, at the west end of the block, the bulk of Taniguchi's new gallery complex looms large. However, because its curtain wall is made of black granite and dark gray glass, and because it received relatively little reflected light from the surrounding buildings, it is virtually transparent. The internal columns and steel decking, and, above all, the work lights that remained illuminated twenty-four hours a day, are readily visible.

Rising above the first setback (slightly above the level of the setback of the City Athletic Club) is the facade of the new high-ceilinged galleries for temporary exhibitions. Set further back above it is the eight-story office tower that crowns the building. The north facade of the tower is rendered as a brilliant white triangle of reflected light, delicately scored by the slim mullions of the fritted-glass panels. The west facade presents a very different pattern of shimmering reflections, and, at its southwest edge, a glimpse of its internal structure (see figure 12).

In a snapshot made in August 2001, Wesely's two cameras—of different dimensions, but containing black-and-white and color plates of essentially equal size—rest atop a mount on the balcony of The University Club before being put into position (see figure 15). Beyond the cameras are the temporary loading docks that would remain for much of the next three years in the emptied sculpture garden, which served as a staging area throughout the period of construction. By June 2004, the docks and the Garden Hall—also prominent in the snapshot—were gone.

The technical success of both exposures from this location provides an unprecedented opportunity to compare long-term exposures in

color and black and white, and the comparison is full of surprises.[5] The monochrome picture features Rachel Whiteread's sculpture *Water Tower* (1998), installed atop the Museum's old two-story Garden Wing, whose second floor was occupied until May 2002 by the Sette MoMA restaurant. Although the sculpture is cast in translucent resin and glows with light, you cannot see through it; that it appears you can in Wesely's black-and-white picture is because it was removed after only ten months of exposure. The Garden Wing was demolished by July 2002, and by January 2003, the much taller structure of Taniguchi's new Education and Research Building had risen on roughly the same footprint. Like its twin pavilion at the west end of the garden, the new building is clad in dark gray glass and black granite, and its presence barely registers in the black-and-white exposure. But the color image clearly articulates the steel framework of the building and the bright orange plastic netting that lined the perimeter of each floor. In the black-and-white image, the diagonal structural elements within the wall of the portico float mysteriously above the temporary loading docks. In the color image, by contrast, the curtain wall is most palpably described at just the same point, where it overlaps the base of the Pelli tower (see figure 13).

Both the portico of the new gallery complex at the west end of the garden (together with the glass facade set back within it) and the office tower above are given more distinct form in the color picture, compared to the black-and-white. Sunlight in midtown Manhattan reflects from nearly every direction, so that even the northern facades of the buildings capture its often-fractured presence. As we would expect, the parallel arcs of the sun are rendered nearly identically in the two pictures, but only the color view describes the shift to

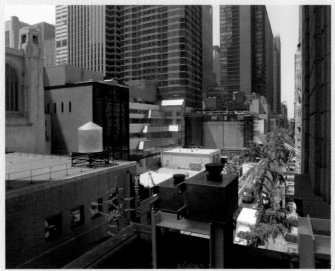

15

shades of orange and red, created by summer sunsets in the distance along 54th Street.

During the exposures, the sun set a thousand times. Instead of a momentary glimpse presented as fact and just as quickly consumed, Michael Wesely's photographs for *Open Shutter* at MoMA offer an experience in which past and present are intertwined elements of an evolving proposition.

1 Boston Mercantile Journal, vol. 14, no. 441 (February 26, 1839), www.daguerre.org/resource/texts/mercant.html.

2 All quotations by Michael Wesely were taken from conversations with the author in April, May, and June 2004, an edited version of which follows this essay.

3 Henri Cartier-Bresson, *The Decisive Moment* (New York: Simon and Schuster, 1952).

4 Readers who wish to understand the Museum's construction project in greater depth, in order to interpret more fully the complex evidence of Wesely's photographs, may find it useful to consult "On the New Museum of Modern Art: Thoughts and Reflections," an essay by Glenn D. Lowry, the Museum's Director, published to accompany the reopening of the Museum, in November 2004. Appearing in the same form in two books, *Designing The Museum of Modern Art* and *The New Museum of Modern Art*, one illustrated with drawings and architectural renderings, the other with photographs, the essay provides a summary of the Museum's building history since 1939, culminating in a succinct analysis of Yoshio Taniguchi's expansion and renovation scheme. Also useful are *Yoshio Taniguchi: Nine Museums*, the catalogue of an exhibition organized by Terence Riley, Chief Curator of Architecture and Design, for the reopening, and *Studies in Modern Art 7: Imagining the Future of The Museum of Modern Art* (1998). All are published by The Museum of Modern Art.

5 Wesely suspects that the black-and-white plate may approach its saturation point more rapidly, thus favoring structures that are visible in the early months of the exposure, while the color plate may register the image more gradually throughout the exposure. It may also be relevant that the black-and-white plate has a single layer of emulsion, which yields a negative. The color plate has three layers of emulsion, each designed to capture a different band of the spectrum, and yields a direct-positive transparency.

INTERVIEW WITH MICHAEL WESELY

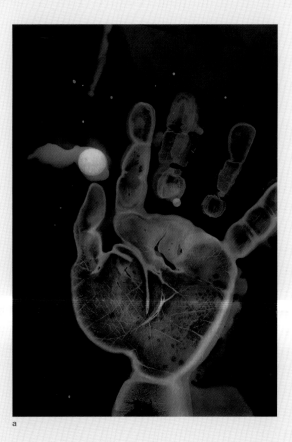

a. Michael Wesely's hand at three months. 1964. Gelatin silver print, 3 9/16 x 2 7/8 in. (10.4 x 7.3 cm). Courtesy Michael Wesely

a

Sarah Hermanson Meister: Let's start at the very beginning. How did you become interested in photography? Do you remember when you first picked up a camera?

Michael Wesely: My father and granduncle were both classic German hobby photographers, and so I grew up with cameras and the dark-room very close by. I was "baptized" with photo chemicals when I was three months old. I own a print of my hand at that age.

My first camera, in '78, was a Canon AE-1. It was advertised all over—this camera was the desired object.

SHM: Do you remember when you first built your own pinhole camera?

MW: It was in '79. The son of my granduncle was with me in those days, and he was very into science. So he explained all about pinhole cameras to me, and we built them together.

Doing this, I also understood the true meaning of "camera." It is an Italian word, and means nothing more nor less than "room." No matter how small this room is today, it is still the same.

SHM: In 1989 you made a piece you called *Summary* (*Zusammenfassung*), in which you rephotographed the contact sheets of the 12,000 negatives you had created up to that point, and printed them together, rendering the individual images essentially indecipherable. Can you talk a little bit about what that work signified regarding your approach to photography?

b

MW: Finishing photo school in Munich in 1988 meant that it was time to think about a career as a photographer, or to go further. Facing my work and exposing myself to the art system was more intriguing to me than starting a professional career as a straight photographer. I was also convinced that having technical skills and knowledge about the history of photography made it possible to be transgressive in a true sense. You can only be transgressive if you know about something from the bottom—history, tradition, rules, and technique.

The work *Zusammenfassung* is a sort of analysis and end point. Looking back after finishing photo school, I tried to figure out why I took photographs all those years when I was a student in high school. Wanting to print my key pictures, the ones that had led me to take more photographs, I made all those contact sheets to start selecting. But I could only see that my taste had changed a lot since the pictures were taken, and that I did not want to print enlargements of certain pictures that I had once liked. I realized how much my perception had changed. And for that reason I treated all the prints the same. So they are only saved as miniatures.

SHM: You seem to be keenly aware of the photographic precedents for your work.

MW: I am a curious person, and so I was always studying and digging into the history of photography; I did my own private research—a self-education. Exploring long exposure time brought up many questions, and I liked the idea of questioning or opposing the idea of the "decisive moment," which in the 1980s was still the main focus of photography.

Defining exposure time by content, independent of technical concerns such as available light, created a big sensation for me. And of course I also found a relative of my work, Harold Edgerton. His ultrashort exposures make us immediately aware of things that are too fast for our eyes to see. His work is a perfect example of the truest importance of photography. Things are taken out of the constant flow of time, and you can look at them as long as you want.

SHM: Are there other photographers whose work especially matters to you?

MW: I think I admire most the work of the old photographers who left a pretty extended statement in photography. Eugène Atget, August Sander, just to mention a couple—these people were haunted by ideas, and it took them decades to see these ideas through photographically.

SHM: You have spoken of the importance of conceptual art to your work.

MW: I always liked the artists who were involved with conceptual art, and I especially liked the early photographic work of Ed Ruscha. His good sense of humor in his concepts made his work very special to me, and pointed out the gap between a photographer whose primary connection is to the physical world and a conceptual photographer whose work is tied foremost to an idea. By linking my exposure time to the subject, I found myself connected to conceptual art. It was very interesting to me, because I realized that with a conceptual foundation, the nature and significance of the visual results change.

This was important to me: being a photographer who is not stuck to just visual effects. Photography for me is not about effects.

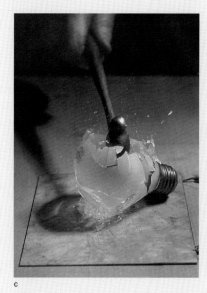

c

d

SHM: What do you mean by visual effects?

MW: It's basically about making an attractive product. So much of the photography world is hunting for visual effects, but this is not about art, it's about shortcuts. Most of my work is a reaction to this existing volume of images. So that's why I'm always talking about… I don't know, there's not a great English translation, but in German it's called *Bilderberg*. *Bilderberg* means a mountain of images. In most of my work I am responding to this enormous volume of existing images, and conceptual art delivered a sort of freedom to me to step away from visual effects.

For example, in 1999, when I installed two cameras on Herrnstrasse, in Munich, I had the chance to photograph the demolition of an old building and the new construction in one photograph. After a twenty-month exposure, I saw how old structures were replaced by a new urban fabric, how trees disappeared, and how all that construction happened while the earth was rotating, represented by the arcs in the sky traced by the sun.

It is important to me that these pictures are intriguing and beautiful, but the beauty is only a secondary product of the concept. I begin with the concept, and when you record life according to the concept, life just looks this way.

And the long exposures…. Many people think they are multilayered—putting a lot of short exposures together…

SHM: …confusing the concept of your long exposures with the idea of time-lapse films, which accelerate time rather than slow it down.

MW: Right. It is essential to reflect upon the relationship between time and space. Otherwise, no real perception is possible. Life becomes so fast that you miss the details that need more time to be appreciated. And some people can't really imagine that you can expose for that long. It's all about the mind frame of the person who is looking at the picture. It's about the invention of slowness, sort of like Sten Nadolny's book *The Discovery of Slowness*.[1] Some things are invisible for physical reasons—they occur too slowly or too quickly to be seen, but other things remain invisible because it would be inappropriate to look for too long—an invasion of someone else's privacy. In my work I am making people look at the things that are usually almost invisible because they are too slow to be noticed. Of course, this way of taking photographs is, in a way, talking about the decisive moment as well….

SHM: Tell me about *The Discovery of Slowness*.

MW: This book describes the life of a man who was always very slow. When he was a small boy, he could not play ball with his friends; the ball was just too fast for him, he could not catch it. Later he became captain of a huge English ship, and then the governor of a British colony, because of his ability to understand so well things that happen more slowly. He could react sensitively to changes in the mood of his crew, or, later, the people of his colony, because he was basically adapted to a different time frame. So what at first looked like a disadvantage became, in fact, his strongest quality.

SHM: You've mentioned that the teachers who had the greatest influence on you were those who looked at photography sculpturally….

e

f

MW: Well, for me it was important that photography not be limited to a two-dimensional approach. Basically, photography for me is about three dimensions. It is also about the camera, how the camera works, and it is not so much about organizing graphic elements in a frame. I did not learn this from the photography world—I learned it from sculpture. In art school I was dealing a lot with sculpture. I had many sculptor friends, and they were, for me, the most intriguing people. They were always working on some sort of installation, and I realized when I looked at their photographs that they had a different idea of space. Their photographs were less about graphic values and more about an intuited sense of volume.

SHM: You have said that the space within the camera is as important to you as the space in front of it.

MW: Yes. My whole body of work is about changing the conditions of the camera, working with the basics of the medium. I made works questioning the conditions of the camera, changing the aperture, changing the position of the film, and I posed these questions to understand photography from the bottom up.

For example, in Salzburg, 1990 was a Mozart jubilee year, and that summer tourists were overcrowding the city, snapping everything everywhere. The gesture of taking pictures made me think about the real intention of photography itself—what you frame and what you exclude. I built my own pinhole cameras and went about taking the same tourist shots. But my camera had no film on the back of the box, where the film would normally be, so nothing that I was aiming at could be registered. Instead, I had all four sidewalls of my cameras covered with film, so the cameras were only recording the surroundings of these places.

Also, there is a large group of works related to the aperture. I used a slit instead of a hole in one of my pinhole cameras, and I went on to make other series, using the slit in vertical position (in my series New York Verticals, from 1995) and horizontal position (in my series American Landscapes, from 1999–2000). These slit cameras were only able to create abstract images—images that question both perception itself and the existing images of the locations I had chosen.

SHM: What inspired you to begin making portraits again?

MW: I was so involved in other work for a while that I was not thinking about portraits. They were always important to me, but I was not actively building a series of them. Right now, with my work in Brasilia, I'm making some portraits of people who were involved in the city's construction (see figure i).

For the early portraits, in '88, I was using pinhole cameras. The longer exposure times came from the small size of the hole. But twenty minutes is already pretty long, so I started thinking about how much time you can ask from a person. I don't think anything much longer than five minutes makes sense, so recently I've been doing portraits with my large-format camera, and they're all around five minutes.

SHM: Let's talk a bit more about your recent work in Brazil. You're making your own twelve-hour, sunrise-to-sunset pictures of modern-day Brasilia and, at the same time, working on a project researching and restoring archival photographs of the creation of the city.

MW: I realized that Brasilia, the capital of Brazil, was South America's big utopian dream of the 1950s—finally executed in 1960 by President

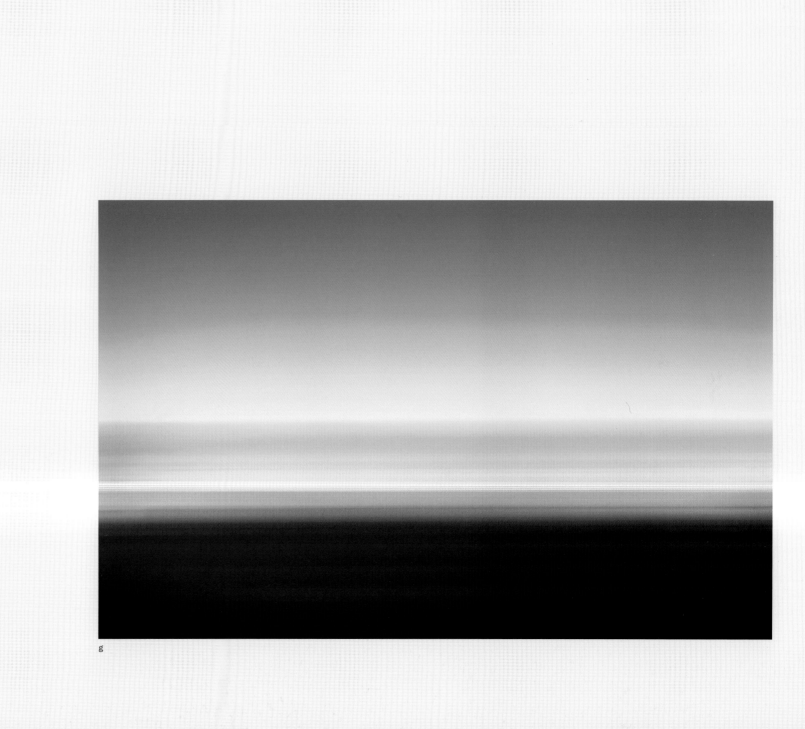

g

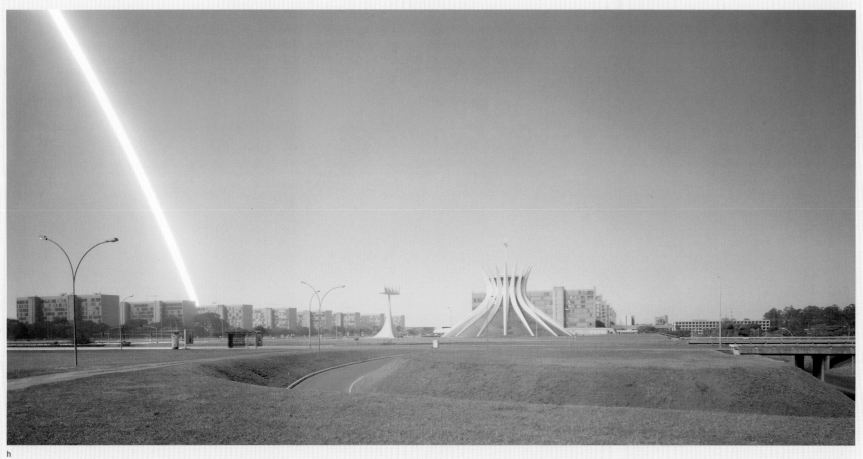

h

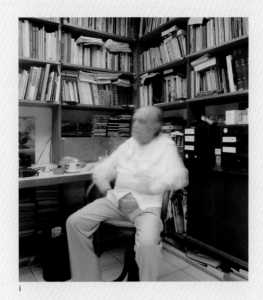

i

h. Michael Wesely. *A Catedral e os Ministérios, Brasília.* 2003. Chromogenic color print, 49 ⅜₆ in. x 6 ft. 28 ⅜ in. (125 x 255 cm). Collection Michael Wesely

i. Michael Wesely. *5 min. Oscar Niemeyer.* 2003. Chromogenic color print, 39 ⅜ x 35 ⅝₆ in. (100 x 90 cm). Collection Michael Wesely

Juscelino Kubitschek, who had the visionary power to do it. Basically, it was the work of two architects: Lucio Costa, who projected the master plan, and Oscar Niemeyer, who created all the official buildings. Brasilia was built into the green desert of the Planalto, a region without any infrastructure.

You can use long exposures to think visually about utopia. You lose the shadows and therefore the sense of orientation, and human life disappears, too. The twelve-hour exposure creates a picture that definitely looks unreal, reminiscent of the architects' drawing tables, where the models are static and without any defined light.

My interest in the pictures from the archives came later, when I was trying to understand more about the city, how it was planned and how the place became livable. I found so much beautiful material that had never before been published, that I decided to rescue and restore these old photographs and include them in my project. Historically, the old photographs are a very important reference.

SHM: Another project I'd like to discuss is Metropolis, which you initiated in Los Angeles in 1999 and expanded in São Paulo more recently (see figures j and k).

MW: I did that project with Kalle Laar, using twenty-minute exposures, which is the time it takes for a record to play on one side. It started with Kalle, who is a composer and musician, and who has a huge archive of vinyl records—everything ever recorded in the history of music. His interest in recording big-city sounds was the initial starting point for creating audio and visual profiles of big cities, and he asked me if we could do it together, using the vinyl disc as a common platform.

If you play the disc, you hear the sounds that Kalle recorded; if you look at it, you see the photograph I exposed during the same twenty minutes.

Usually, sound and photography do not really fit together because sound and music reveal themselves over a certain length of time and photography is always about a specific moment. But since long exposures are not about capturing moments, the two mediums fit together pretty well on these vinyl records—they even create an interaction. We did a test in Los Angeles, and then we made the first complete and bigger set of recordings in São Paulo.

SHM: And when you were in São Paulo, you were struck by how the sounds were different from those in Los Angeles?

MW: It sounds strange, but in fact when you really listen to twenty minutes of a traffic jam in São Paulo, you think, "Oh, this traffic jam sounds very different from a traffic jam in New York," because New York has no Volkswagens. The Volkswagen sound is a very special sound that you still hear a lot in South America. In Germany it has disappeared completely. When you think of a traffic jam in Rome, there are lots of Vespas, lots of small motorbikes, and they're always honking around, there's a completely different lifestyle on the street. A traffic jam in Los Angeles is, of course, very different, too—not many motorbikes, only cars, five lanes, ten lanes…. So every city has a specific sound, but we are not used to paying attention to sound because we are exposed to it all day and we ignore it subconsciously. We know that it's there, but we don't hear it.

SHM: In the same way that we witness passing time—we see it and yet we don't see it…. Your focus on the specific fabric of an urban

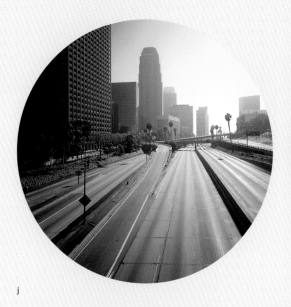

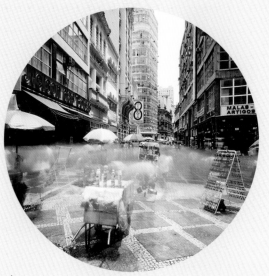

j k

location is not limited to the Metropolis project. You've been photo-
graphing in Berlin since the early 1990s, first with your pinhole
cameras, and then, since 1997, with your large-format cameras,
making long exposures.

MW: I think with Berlin, the whole story of changes is bigger than it
looks from an American perspective. It was really depressing to have
the wall: you could not go east, and the Cold War was always kind of
frightening. I was born in '63, and for many years lived with this sepa-
ration—the Russians, the Americans, the Cold War, all these stories
that were dictating our lives on a certain level. And it was especially
strange to have a separate German country in the east. This was such
a big issue in my youth.

I was already exploring aspects of time in photography, and then
suddenly there was this breaking down of the wall. There were tremen-
dous changes that were especially visible in Berlin, because Berlin
itself was divided. All of the youth in Germany was so excited that
basically everybody who could, moved to Berlin, so it became a big
party place for every sort of adventure that you can imagine. I didn't
move to Berlin right away, but I visited almost every year to see all
the changes. Being aware of this important political moment was an
obvious step for my work with long exposures. I was fascinated by
how urban space was changing and how long exposures could show
these changes. During the two years that my cameras were trained
on Potsdamer Platz, big economic and social changes came about and
affected the lives of everyone there. All of this occurred in front of the
lenses—all captured—but almost none of it visible—in the photographs.

And talking about changes and structures, you have this in the MoMA

pictures, too. How you can see certain things, and then later you can-
not see them anymore—how the building is halfway visible, halfway
invisible.... This describes for me a very interesting moment (if you can
call three years a moment). It's the moment when the building is born.

SHM: Your conception of a moment, I think, is very different from most!

MW: Wait a little bit. You know, in twenty years people will think
differently about the pictures from Potsdamer Platz. These two-year
exposures will just look like a short moment in history. The construc-
tion around Potsdamer Platz is finished, but on the east end there
is Leipziger Platz, where the construction is still in progress. I have
cameras still going there, because a few years from now this process
will only be visible in my pictures. They are an artistic documentation
of the changes in the urban landscape—and of course they carry all
the background of political change.

SHM: Do you have a goal or end point in mind for this body of work?

MW: No. Every city is involved in constant transformation, and so I'm
not really ready to say that this has an end.

SHM: Let's talk about the World Trade Center....

MW: That is a really important project, because it is big—not just
sculpturally speaking. It represents a politically decisive moment in
history, in the same way that the changes in Berlin were very big.
For me, taking pictures of the rebuilding of the World Trade Center
site is not an apology for capitalism. It is more about the anthropo-
logical side, historically speaking.

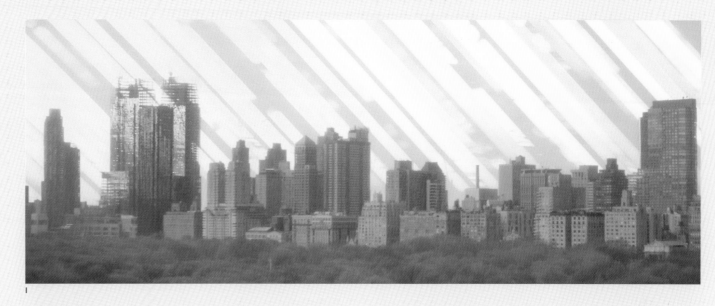
I

Basically, the pictures that I made for The Museum of Modern Art are images that were taken in a new political age. We were lucky to have set up the cameras right before September 11.

SHM: Do you think you'll ever reach a point where the negative doesn't register any more change?

MW: No, because now it's basically about ten, twenty, forty years exposure time, and I have discovered that I can make ten-year exposures. But now it gets more complicated—it's more about who will process a transparency in fifty years, and what will happen with film that is left inside a camera for fifty years. And, of course, it will soon be a question of my own mortality....

SHM: So do you have any longer-term projects in mind right now?

MW: I would like to make some nature pictures—I don't know, maybe a mountain, a twenty-year exposure, something like that. And this has already started, with the Central Park picture. New York has always fascinated me—all the dynamics on the street, all these businesspeople hunting for their careers.... And then you get involved yourself, and you look up at the sky and see the clouds moving very slowly, and then you get a different layer of time. The view looking across Central Park is basically a more philosophical statement—as if the camera were a giant, or a stone sculpture, sitting on the rooftops and watching, living in another time frame.

SHM: The Central Park picture and several other of your long-term exposures are in color. Are color and black and white interchangeable in your mind, or is there a philosophical distinction between the two?

MW: It's an ongoing process to find out about color values. Talking with my technicians always brings up new details, new issues. For example, the Central Park picture shows that you have the sun in the sky, and in some parts the sun made one line, and this line is very shiny, it has this sort of white light—it creates a white line on the film. But then for the other days in the same place there is mostly blue sky, and so over the course of the exposure the white line turns bluish. We get a modification in the sky that was not visible with black-and-white negatives. It's all a new experiment to find out how color affects the results, and I cannot yet explain it completely. We need more color photos of this length so that perhaps we'll understand in some years why in certain areas the path of the sun looks white or yellow instead of blue.

You also see that the sunsets in summer are redder than in winter—things that when you are looking at a black-and-white picture you don't even think about, but that the color picture makes obvious, visible.

SHM: Do you think that makes your color pictures about something else?

MW: All photography is always about understanding or realizing certain things, and for that reason it has always been appreciated. It delivers information that gives you another vision or perspective. And so the color pictures fulfill the job that photography has been doing for the world for many, many years now.

1 Sten Nadolny, *The Discovery of Slowness*. Translated by Ralph Freedman (New York: Penguin Books, 1997).

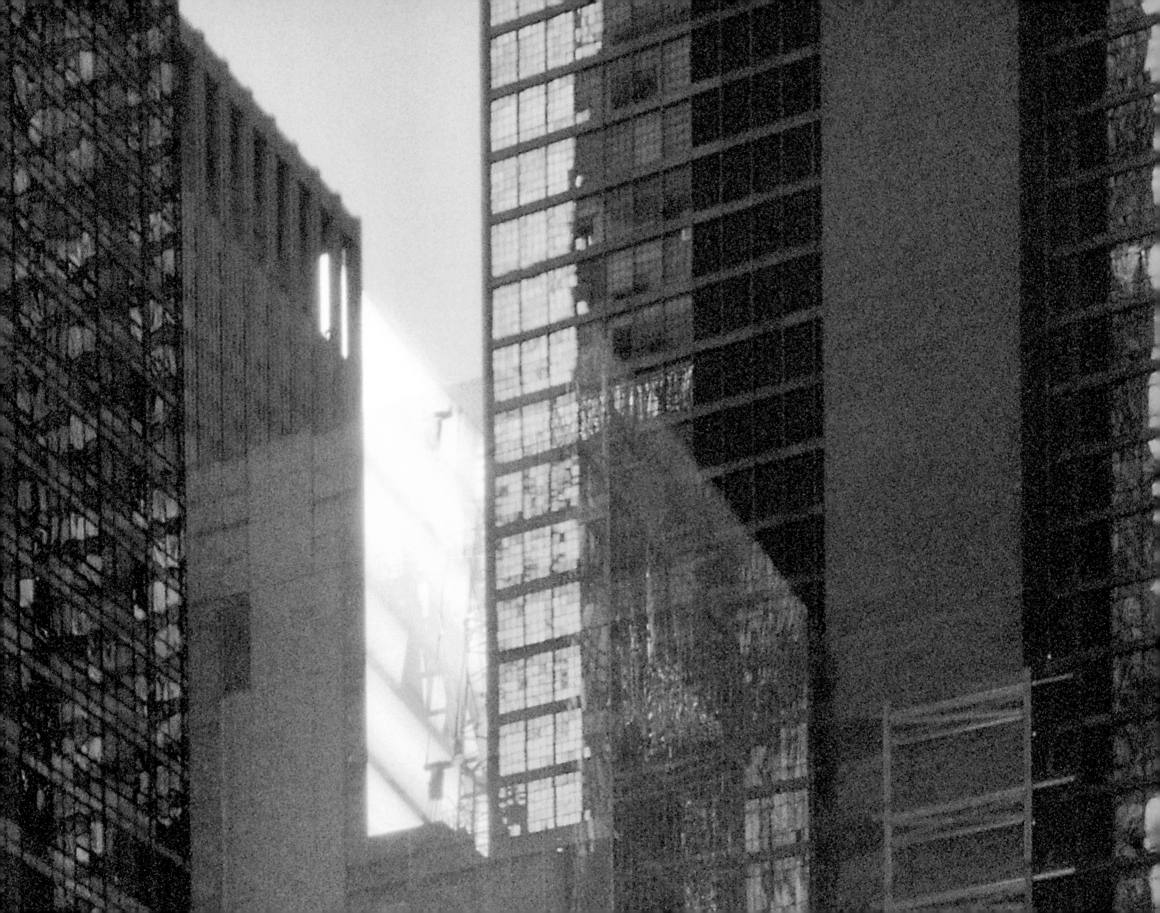

OPEN SHUTTER

AT THE MUSEUM OF MODERN ART

15.6.2001–18.2.2003
The Museum of Modern Art,
New York

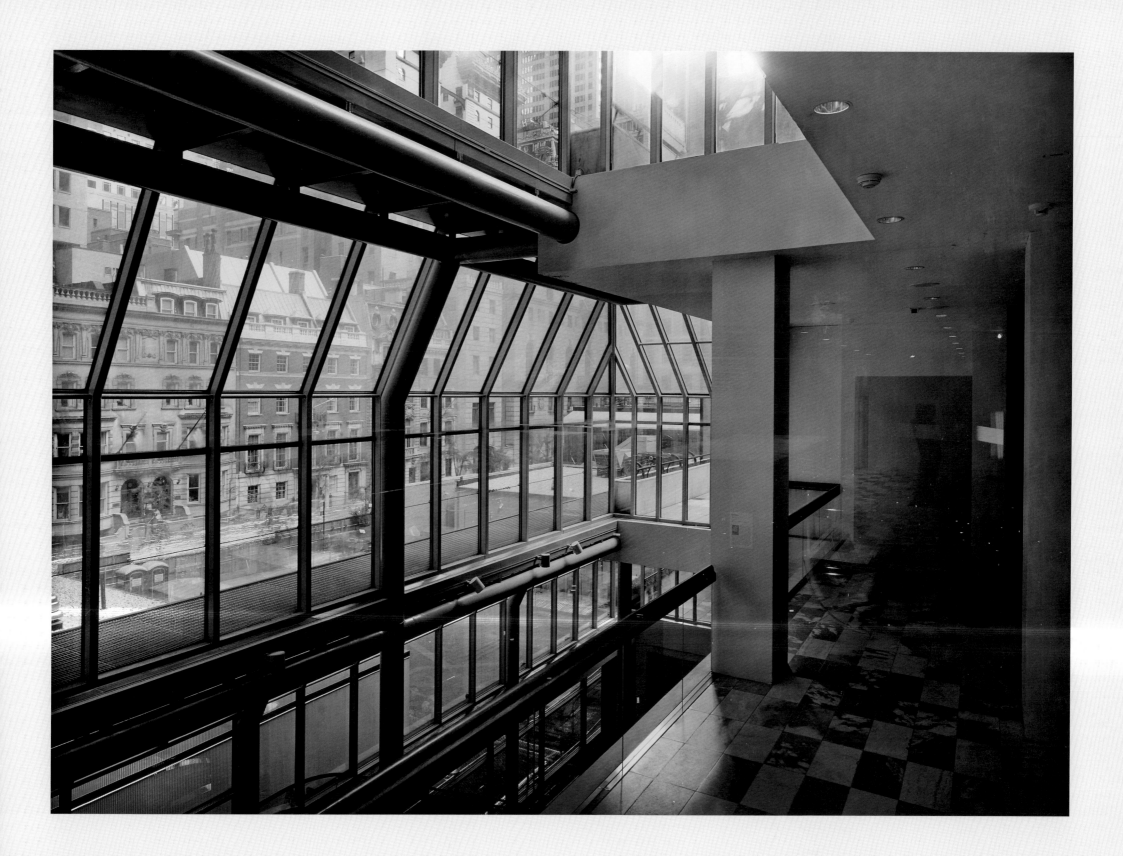

9.8.2001–2.5.2003
The Museum of Modern Art,
New York
(detail on following spread)

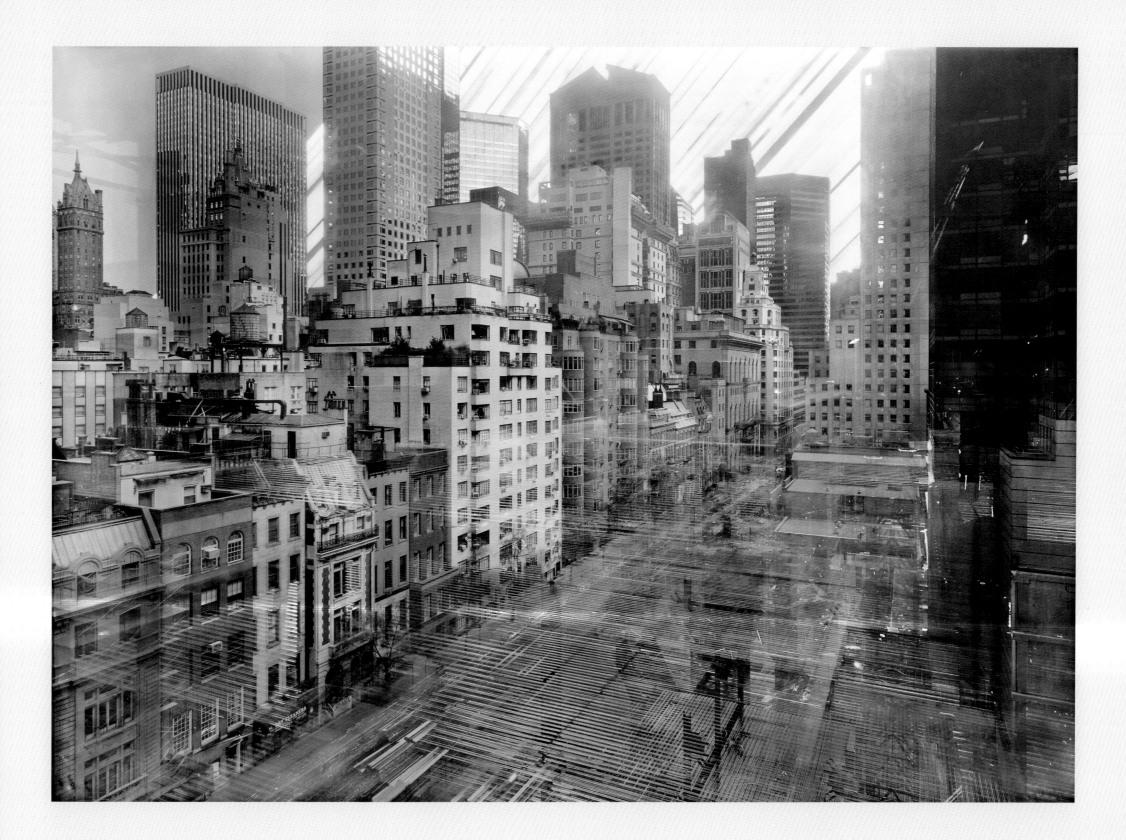

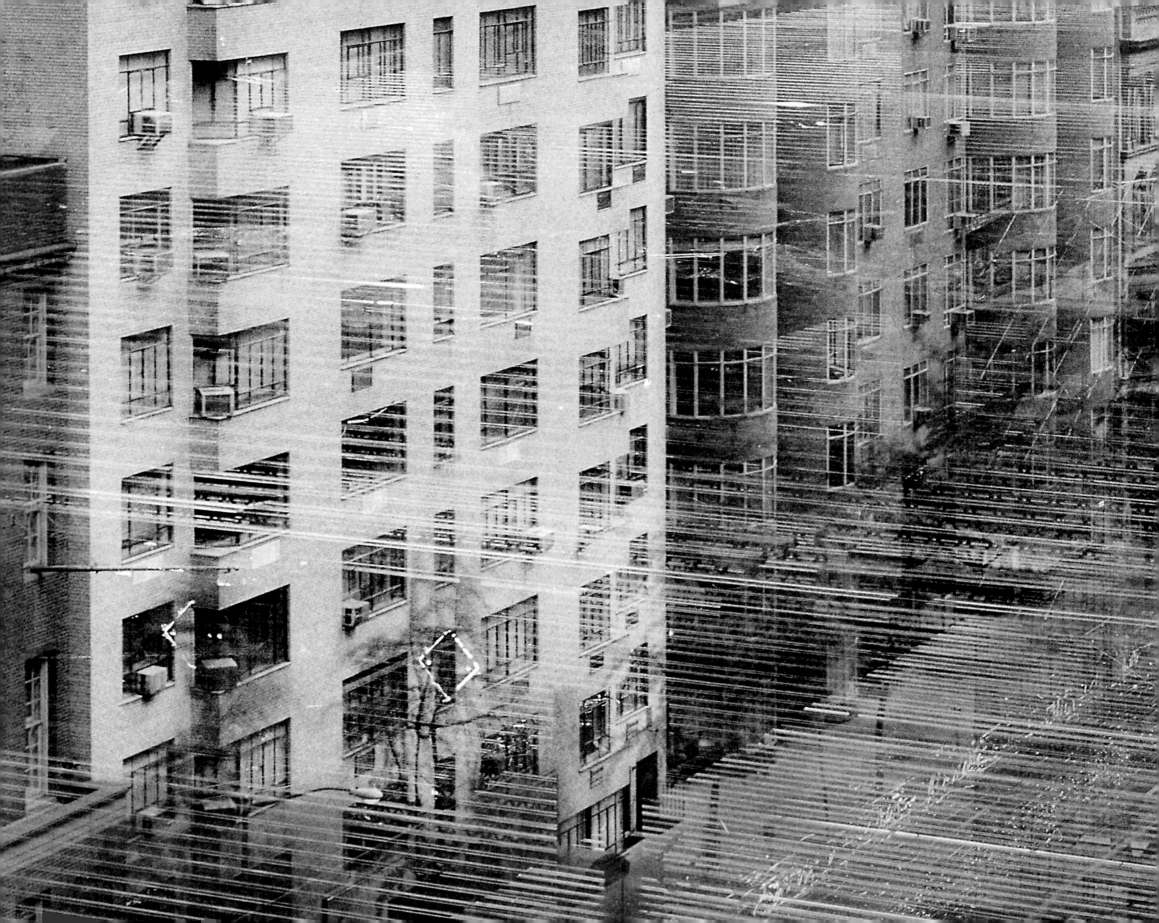

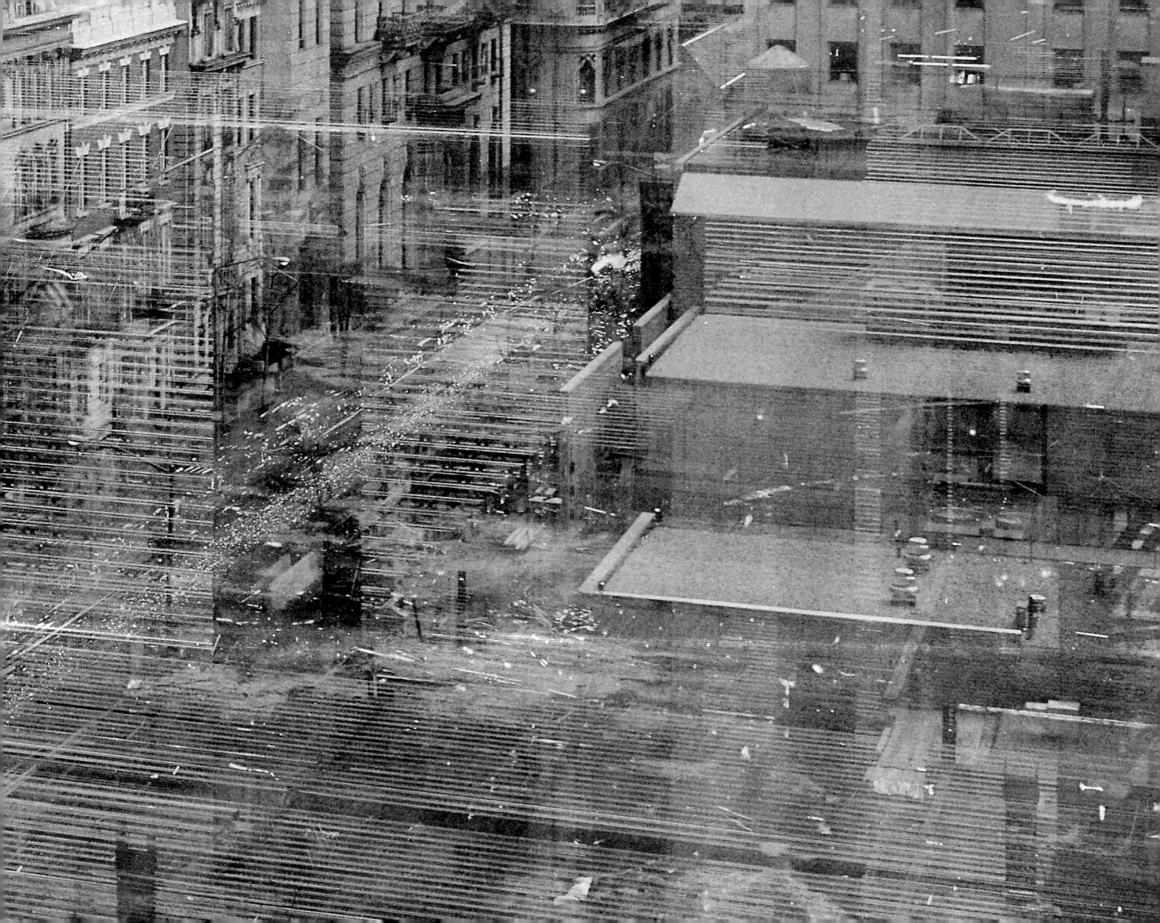

9.8.2001–7.6.2004
**The Museum of Modern Art,
New York**
(details on following spread)

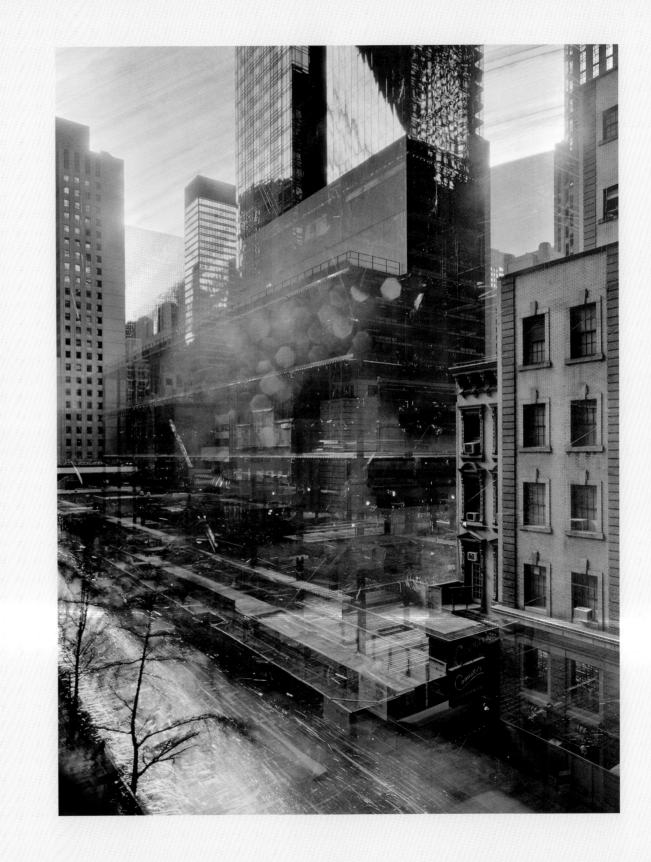

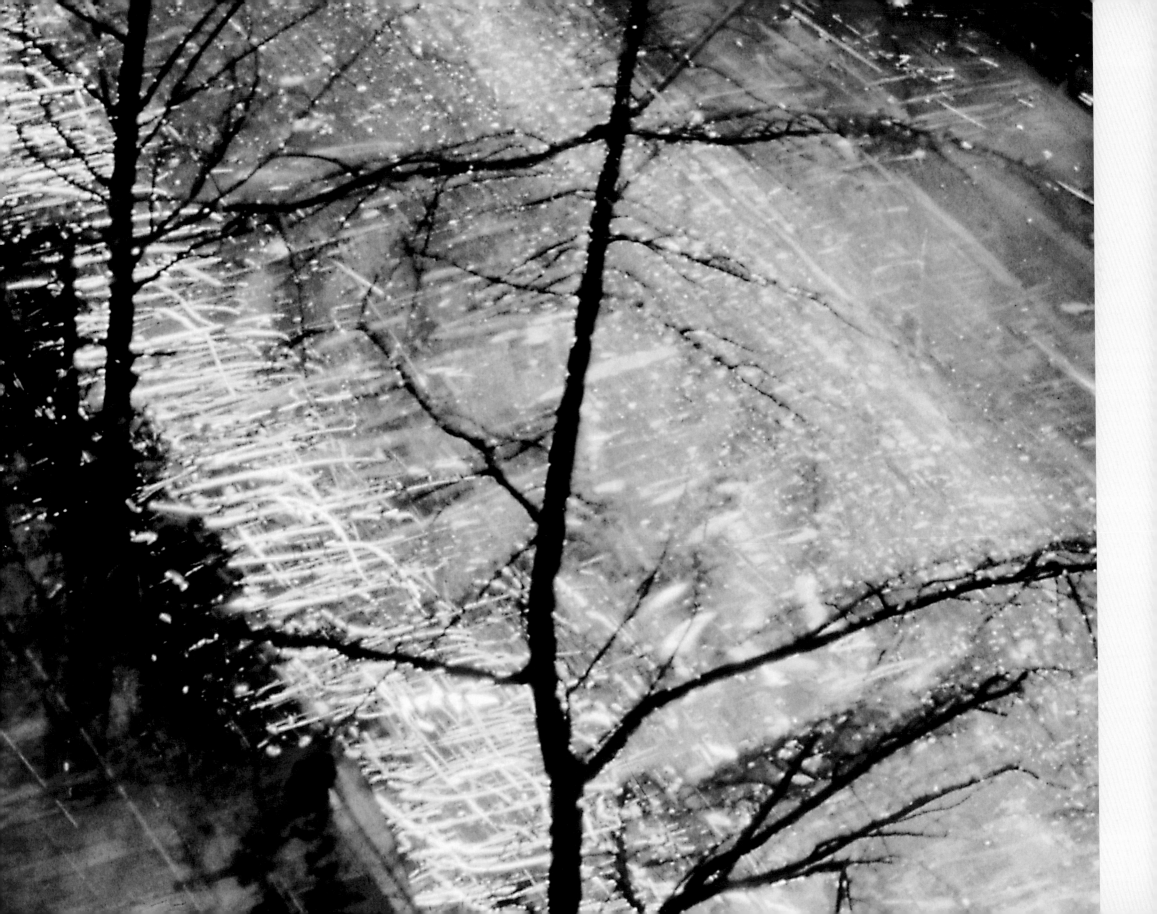

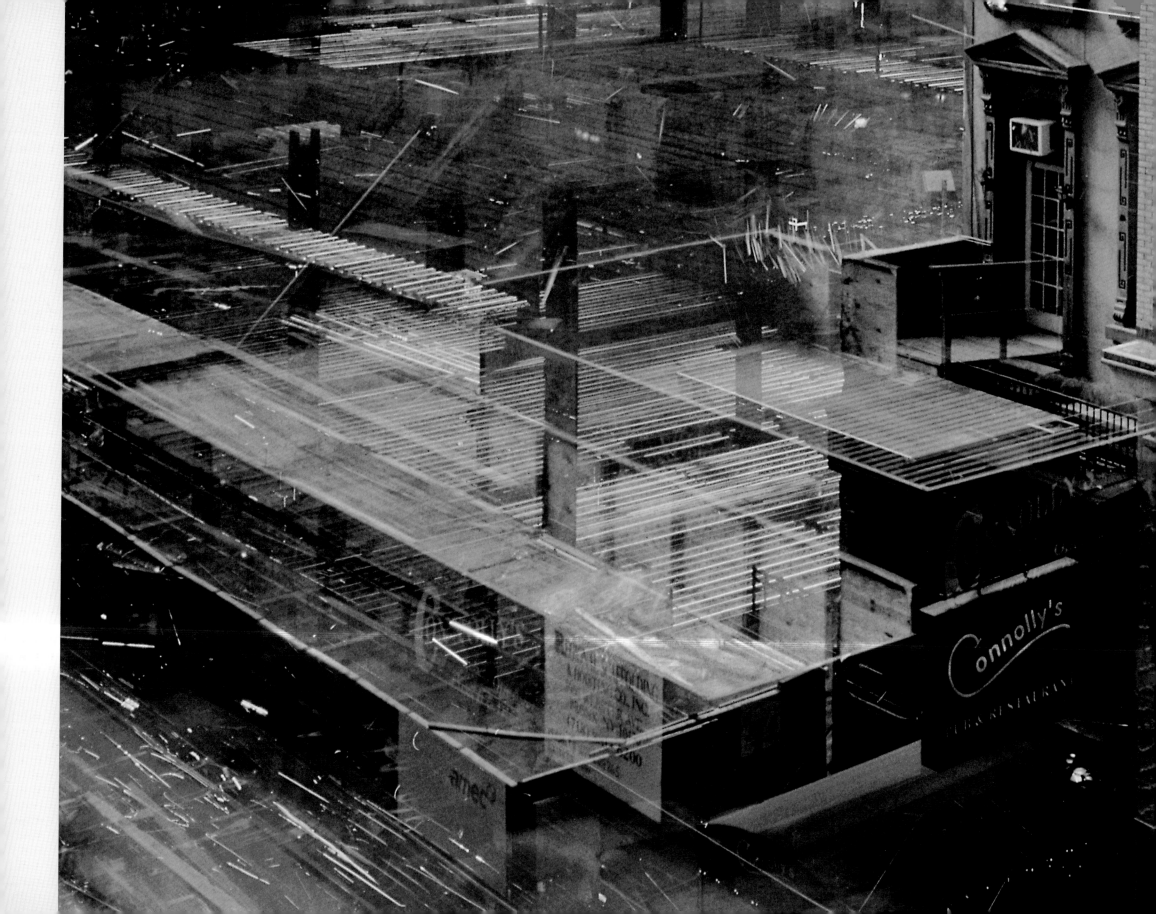

7.8.2001–7.6.2004
The Museum of Modern Art,
New York
(details on following spread)

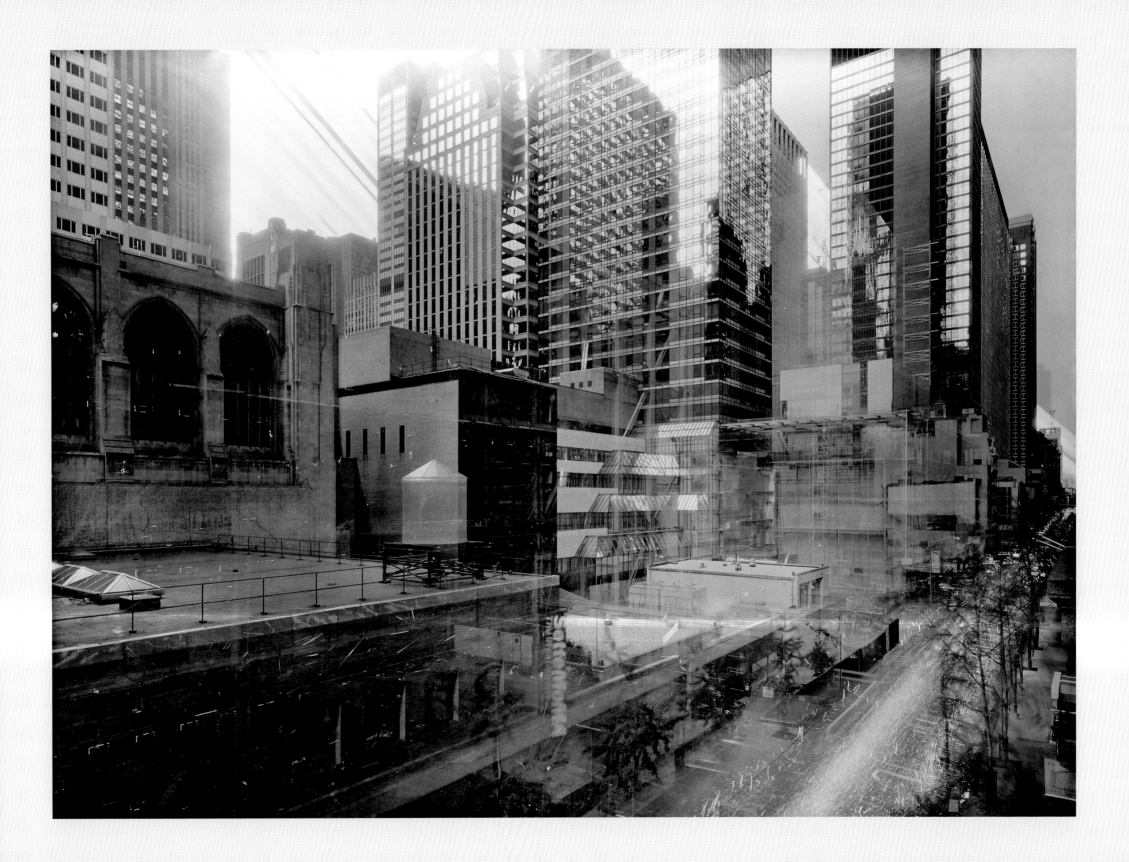

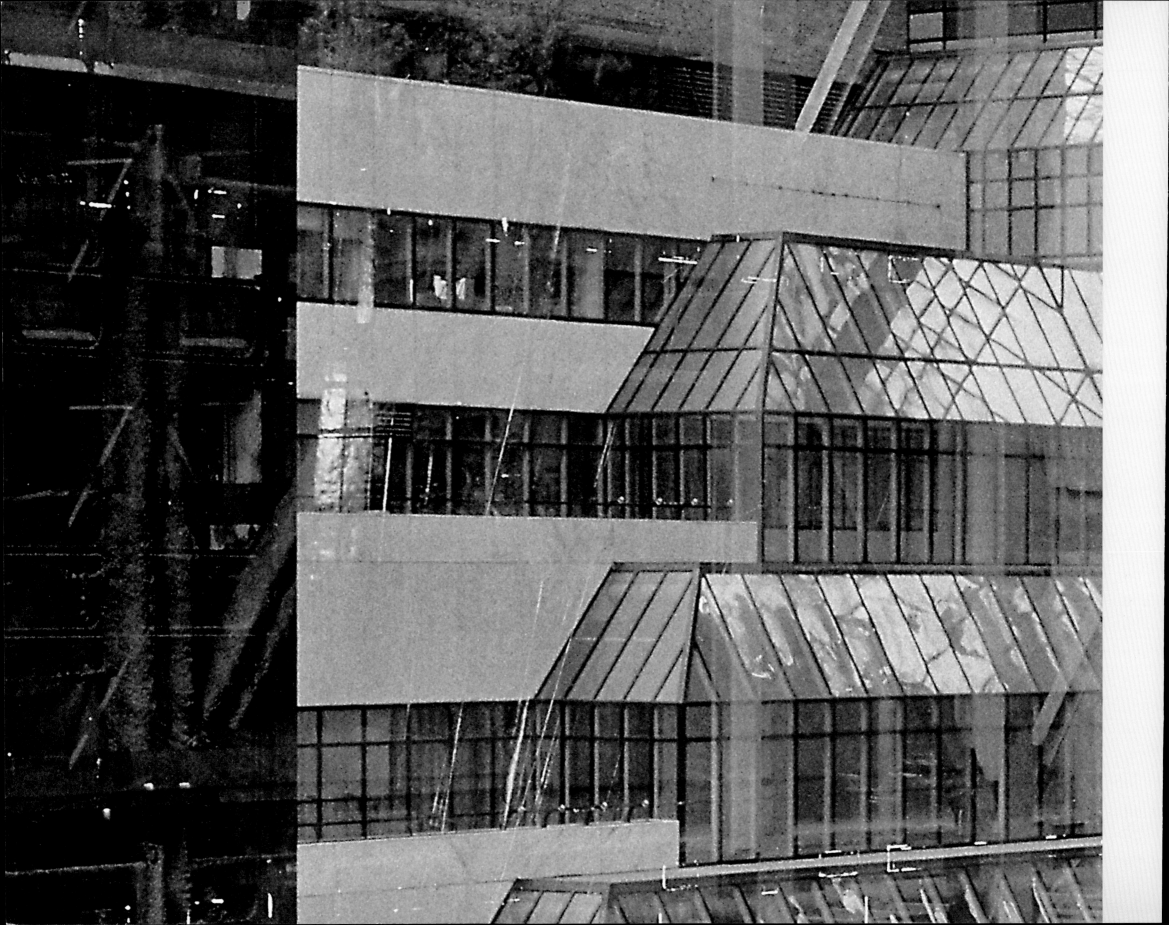

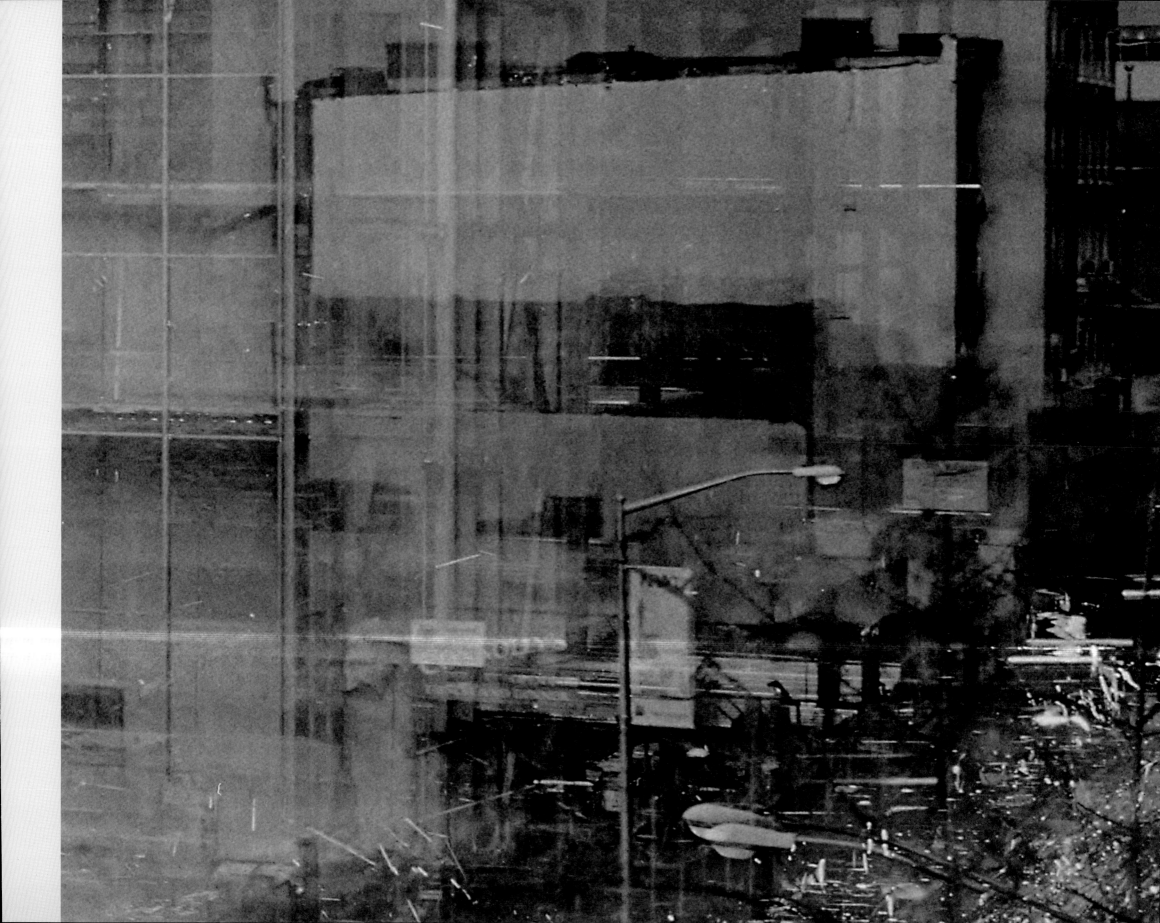

7.8.2001–7.6.2004
The Museum of Modern Art,
New York
(detail on page 30)

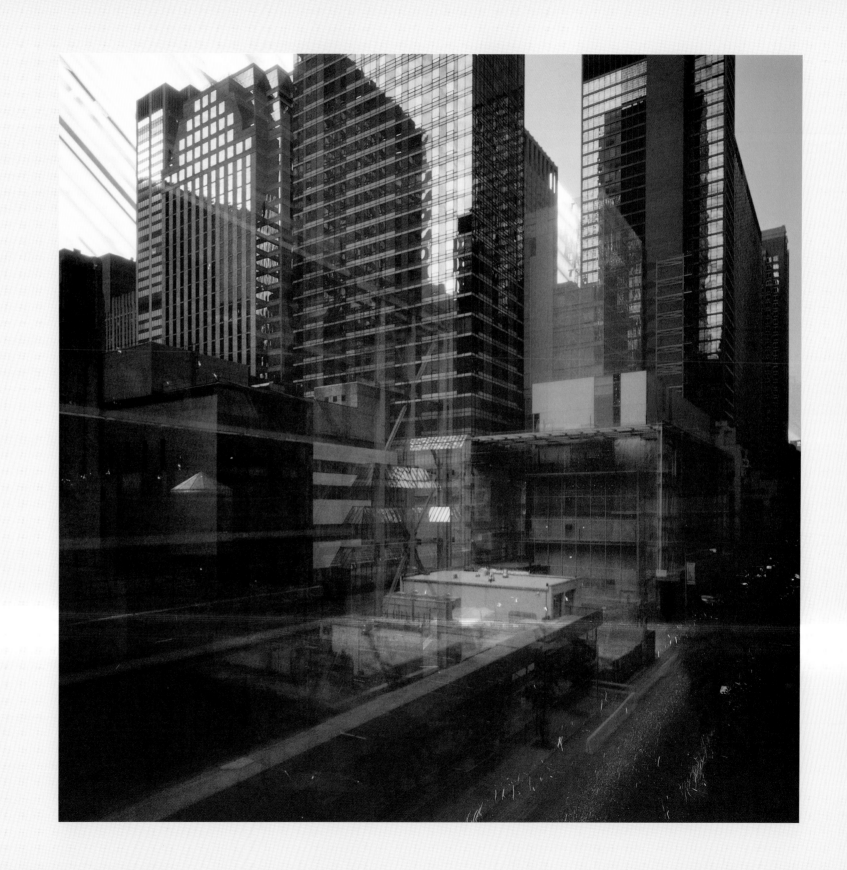

LONG EXPOSURES

1997–2003

19.3.1997–3.9.1997 Krefeld

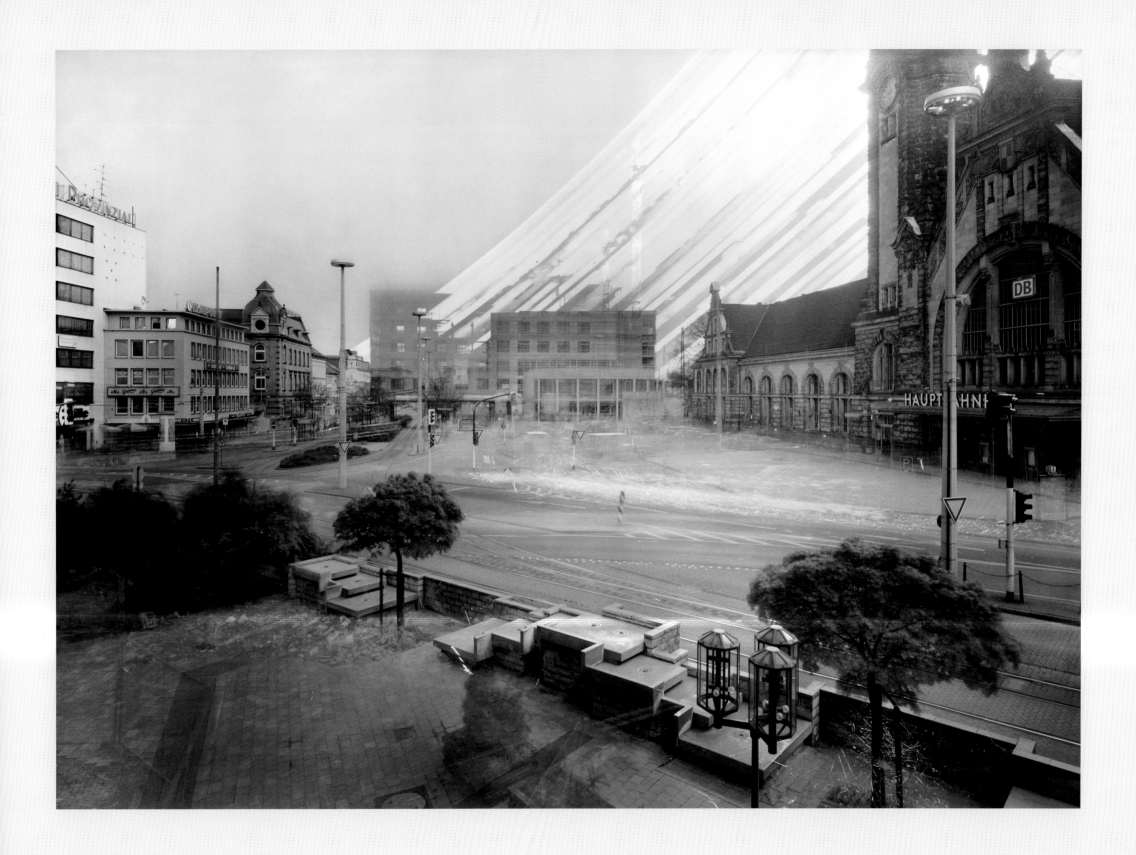

27.3.1997–13.12.1998
Potsdamer Platz, Berlin

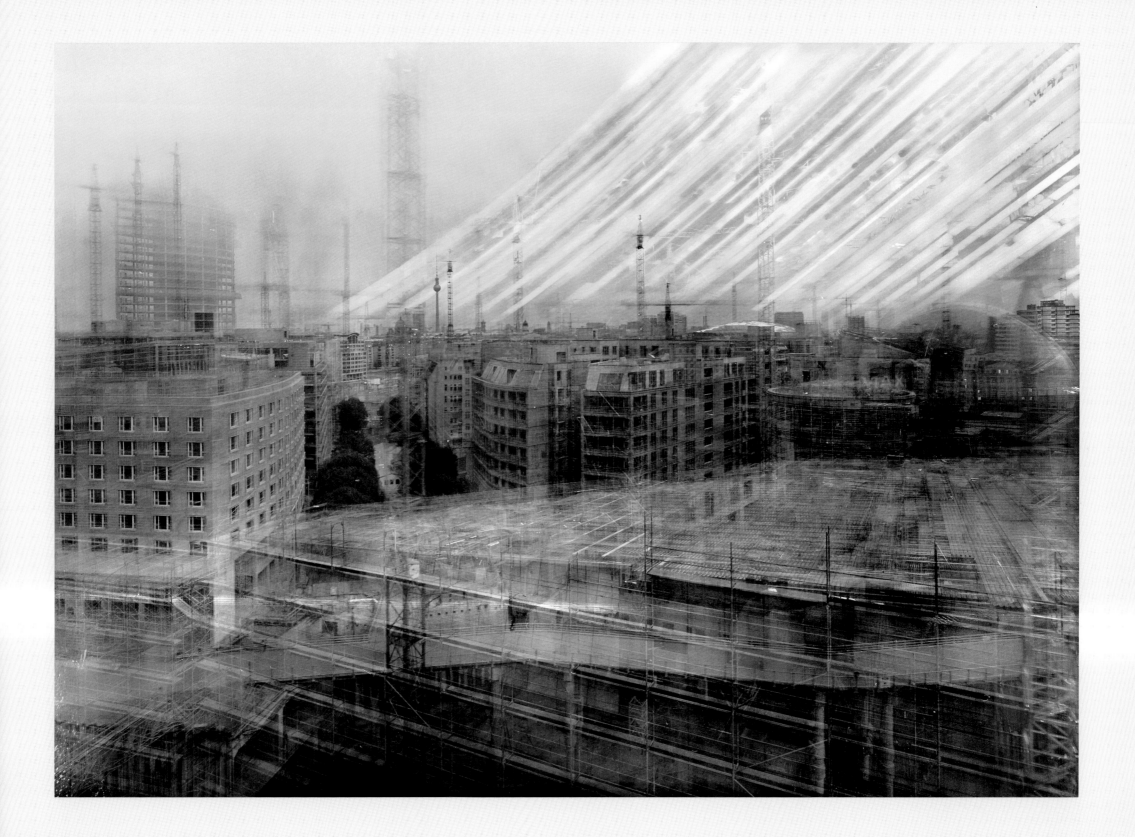

4.4.1997–4.6.1999
Potsdamer Platz, Berlin

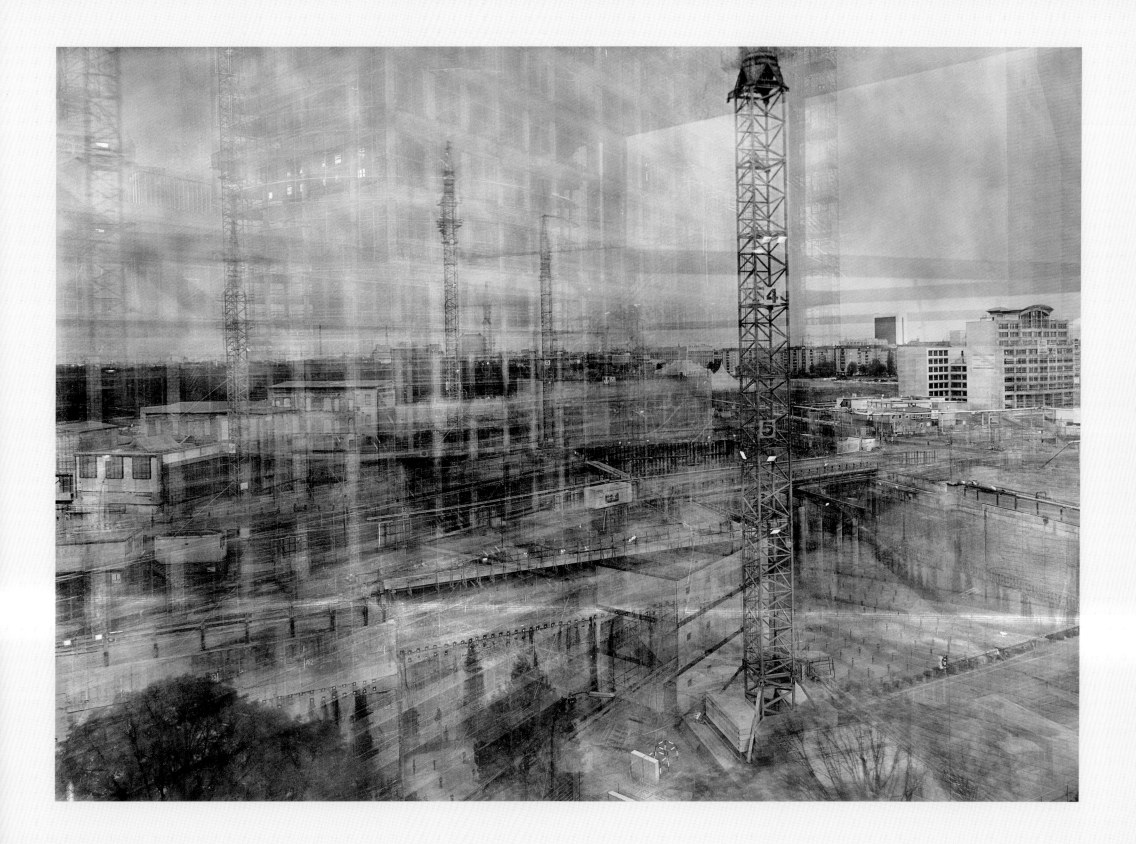

5.4.1997–24.9.1998
Potsdamer Platz, Berlin

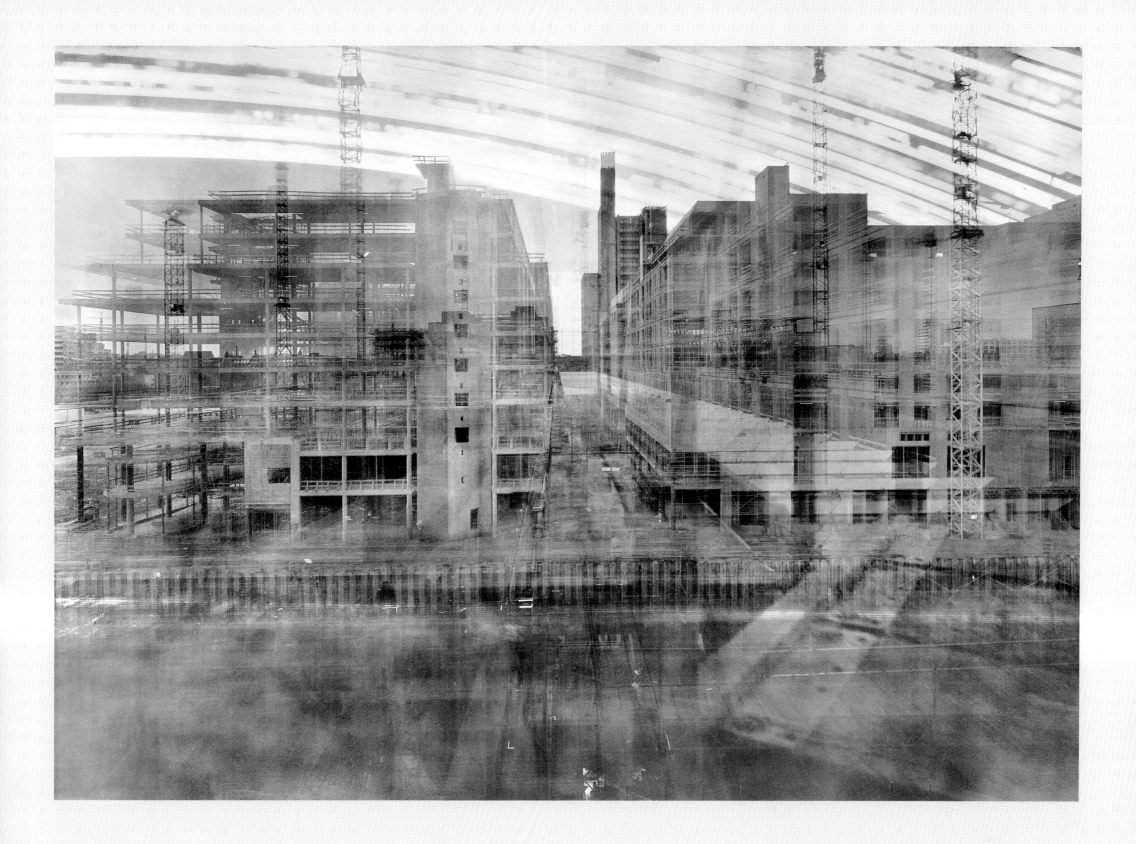

5.4.1997–3.6.1999
Potsdamer Platz, Berlin

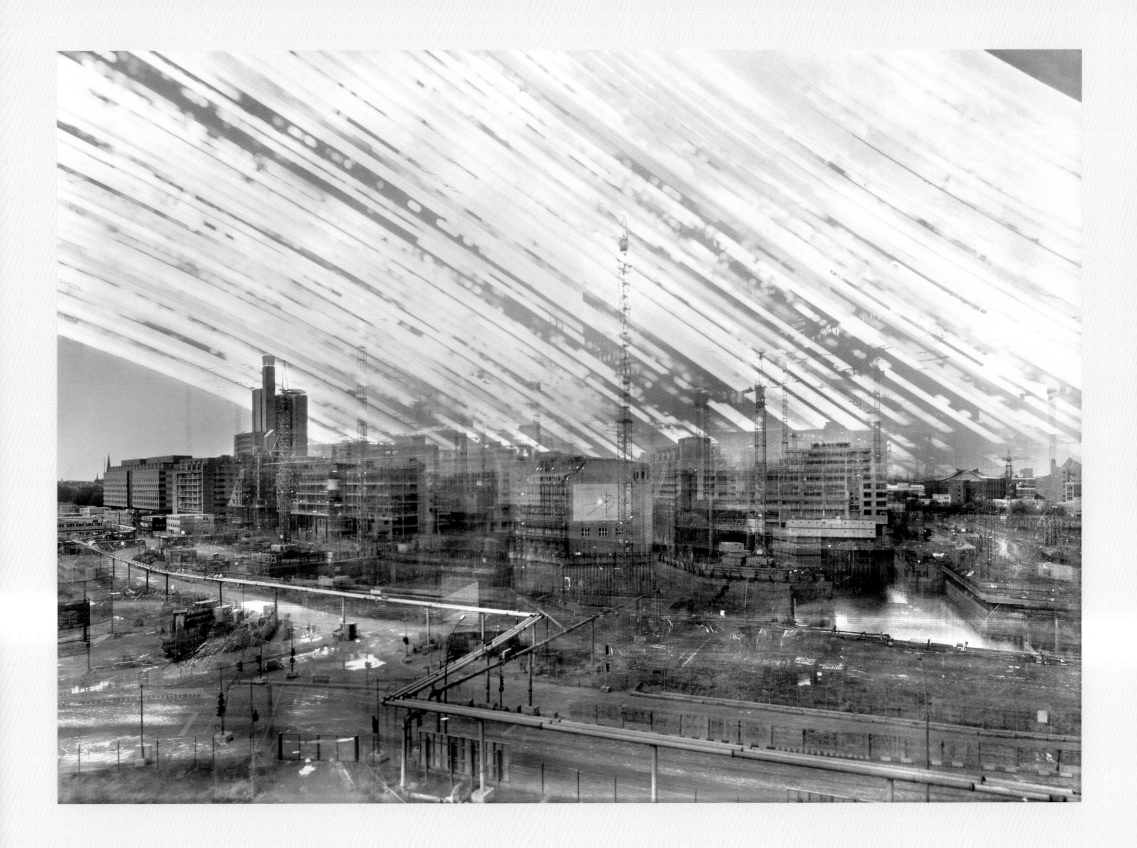

8.1.1998–16.9.2002
Pinakothek der Moderne,
Munich

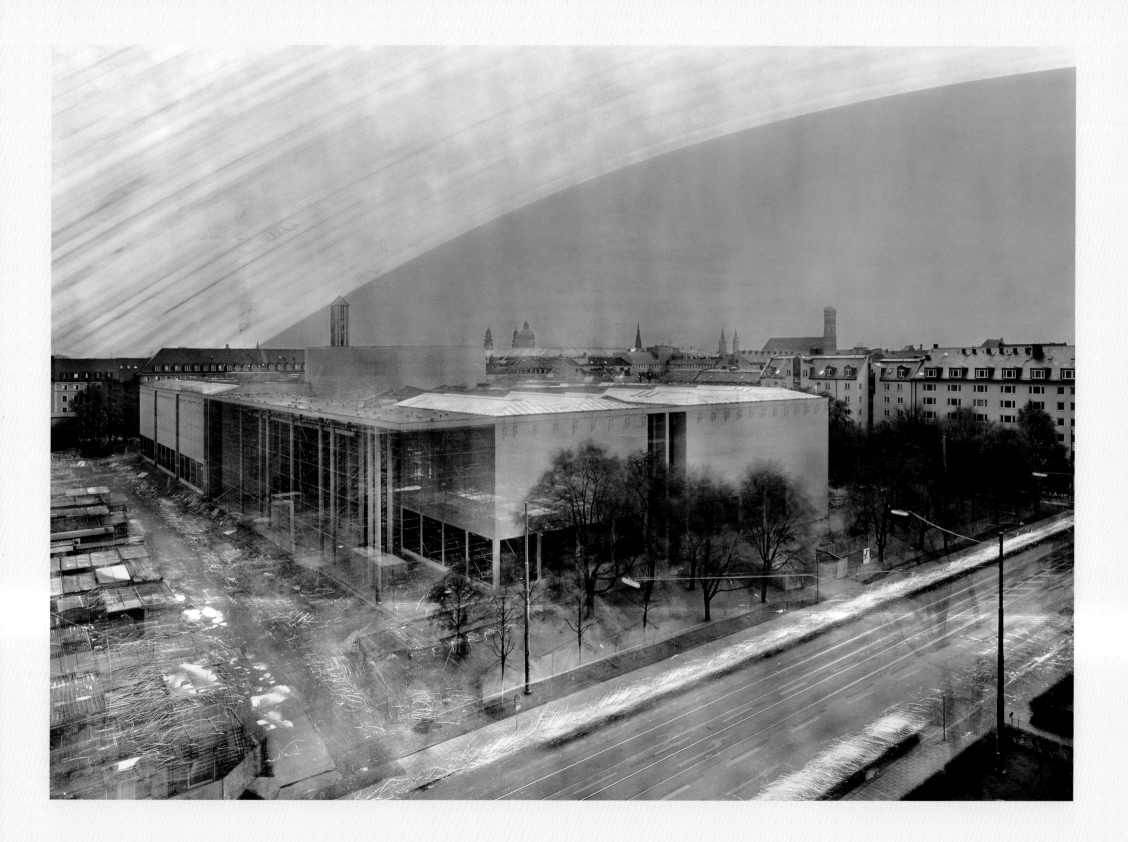

20.5.1998–18.5.1999
Pariser Platz, Berlin

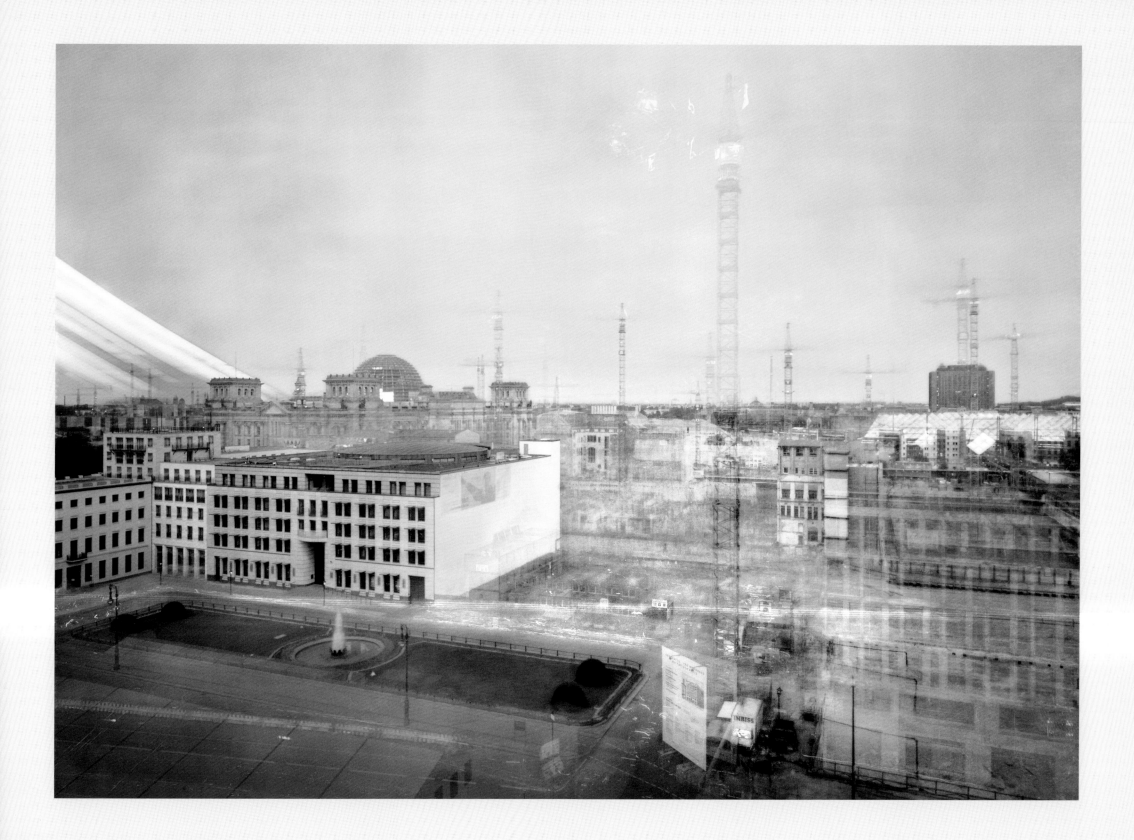

9.4.1999–11.12.2000
Herrnstrasse, Munich

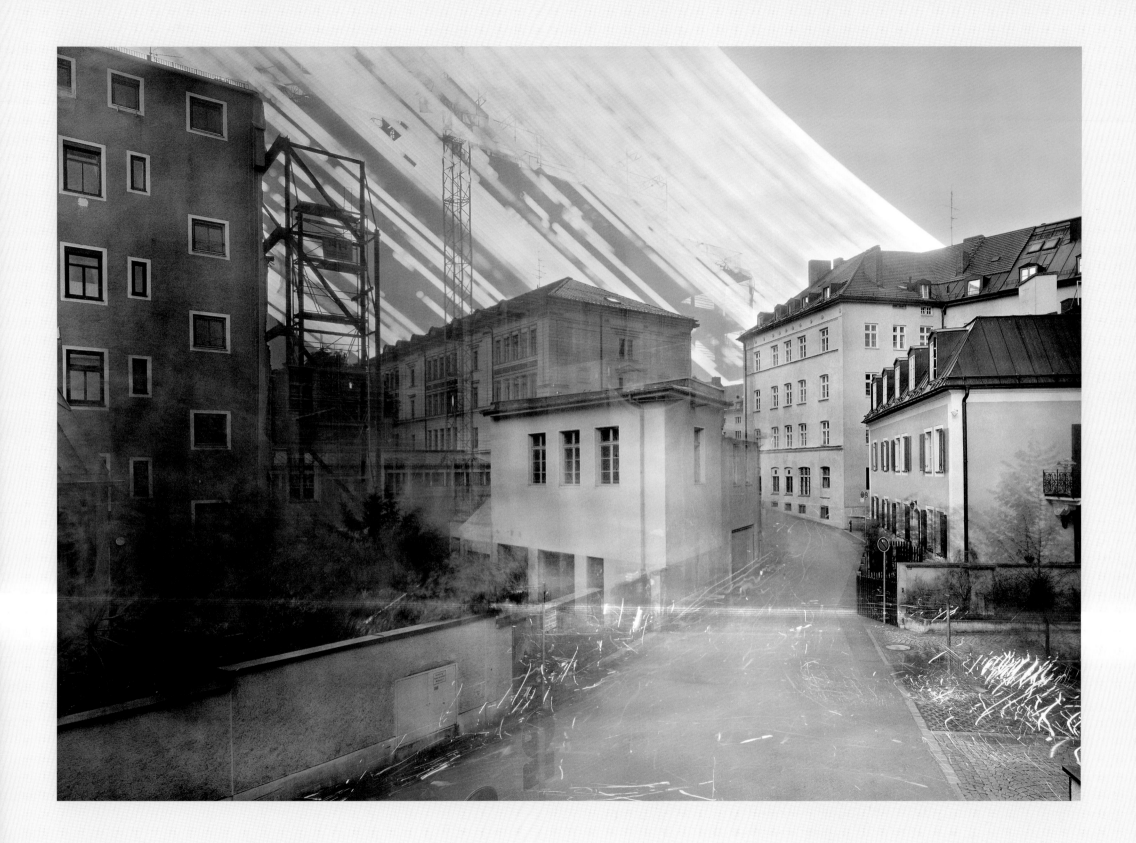

14.4.1999–11.12.2000
Herrnstrasse, Munich

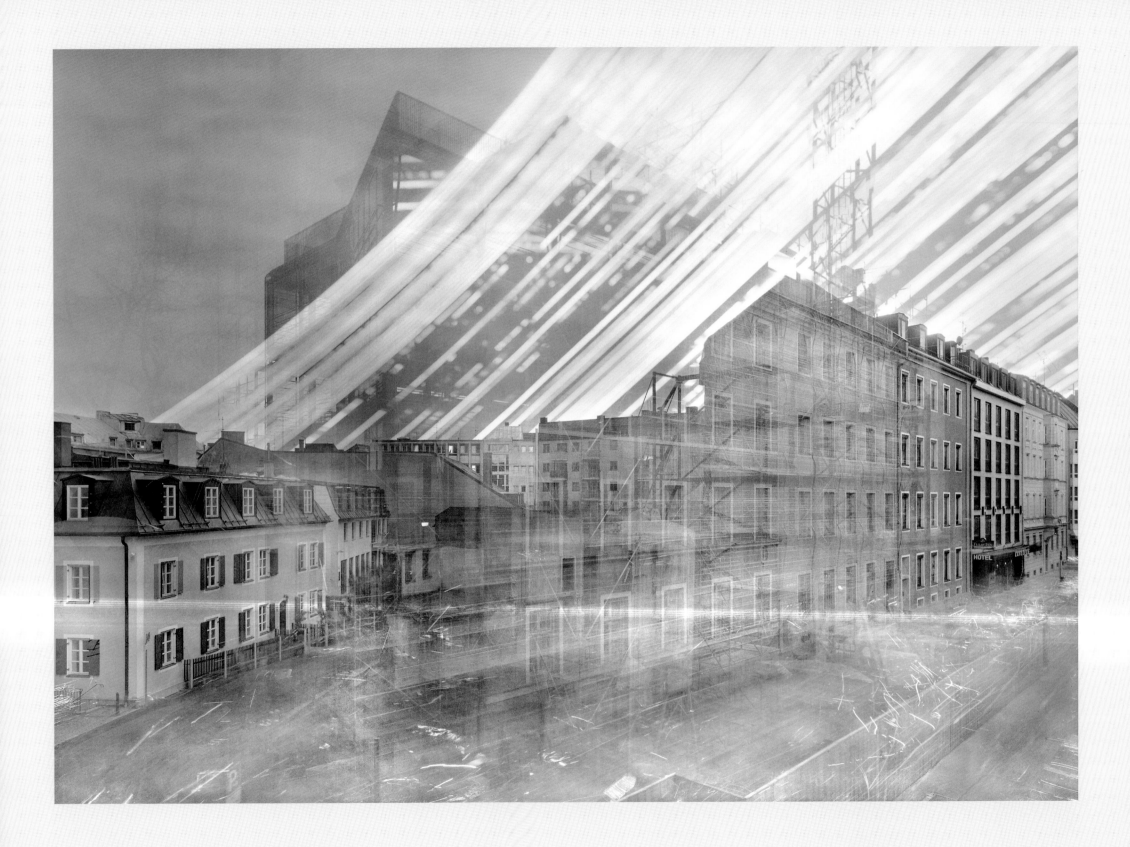

5.8.1999–6.12.2000
Leipziger Platz, Berlin

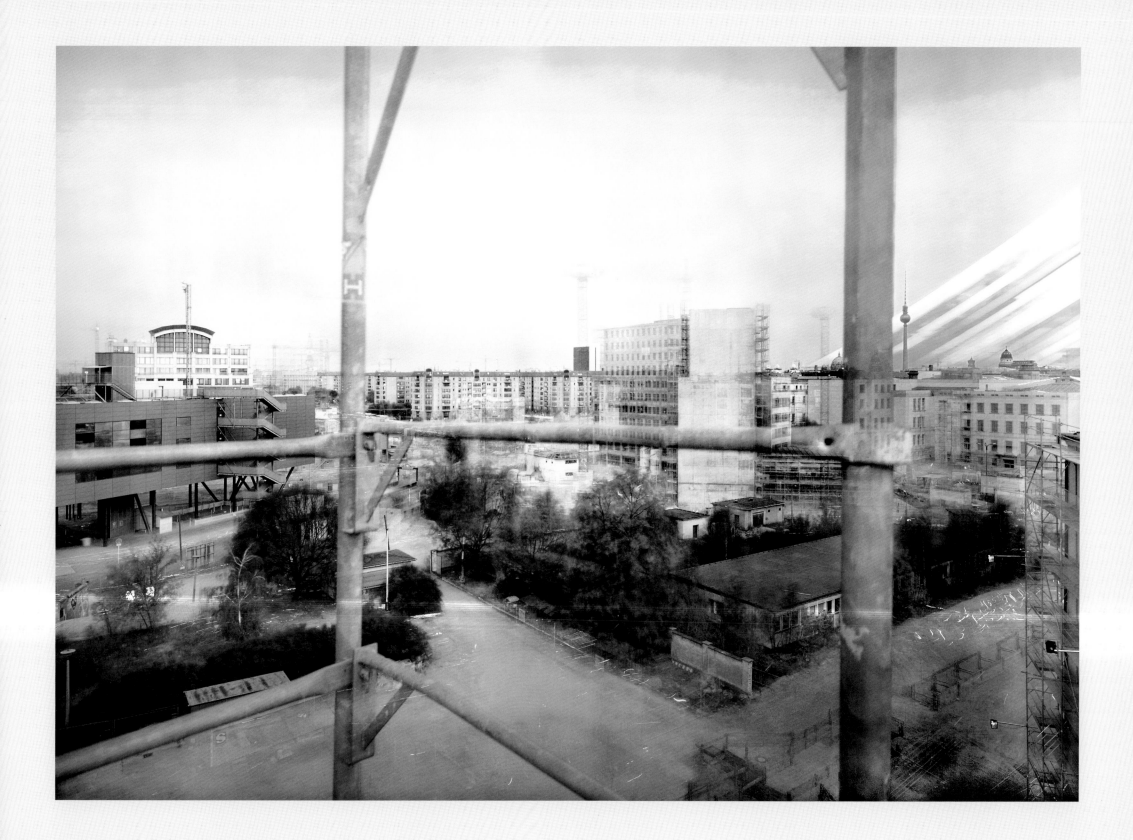

6.8.1999–6.12.2000
Leipziger Platz, Berlin

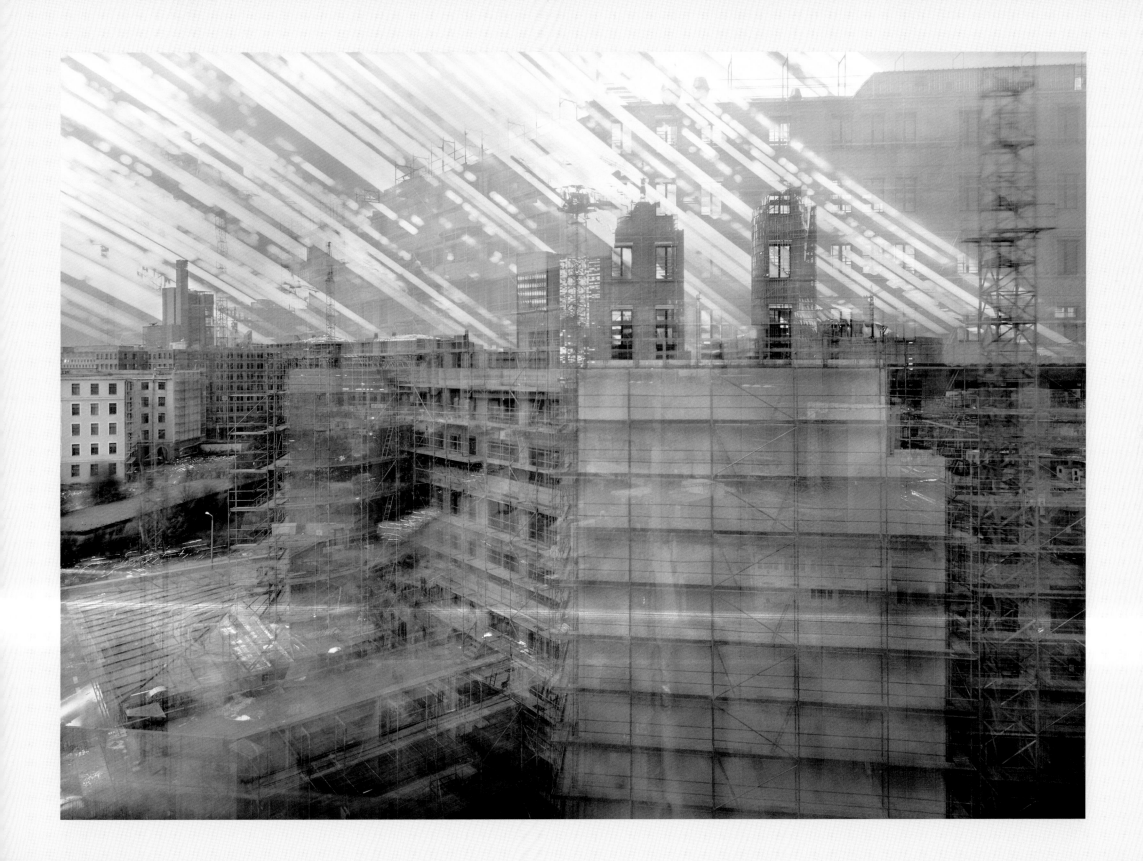

25.7.2000–3.6.2003
Dresdner Bank, Frankfurt

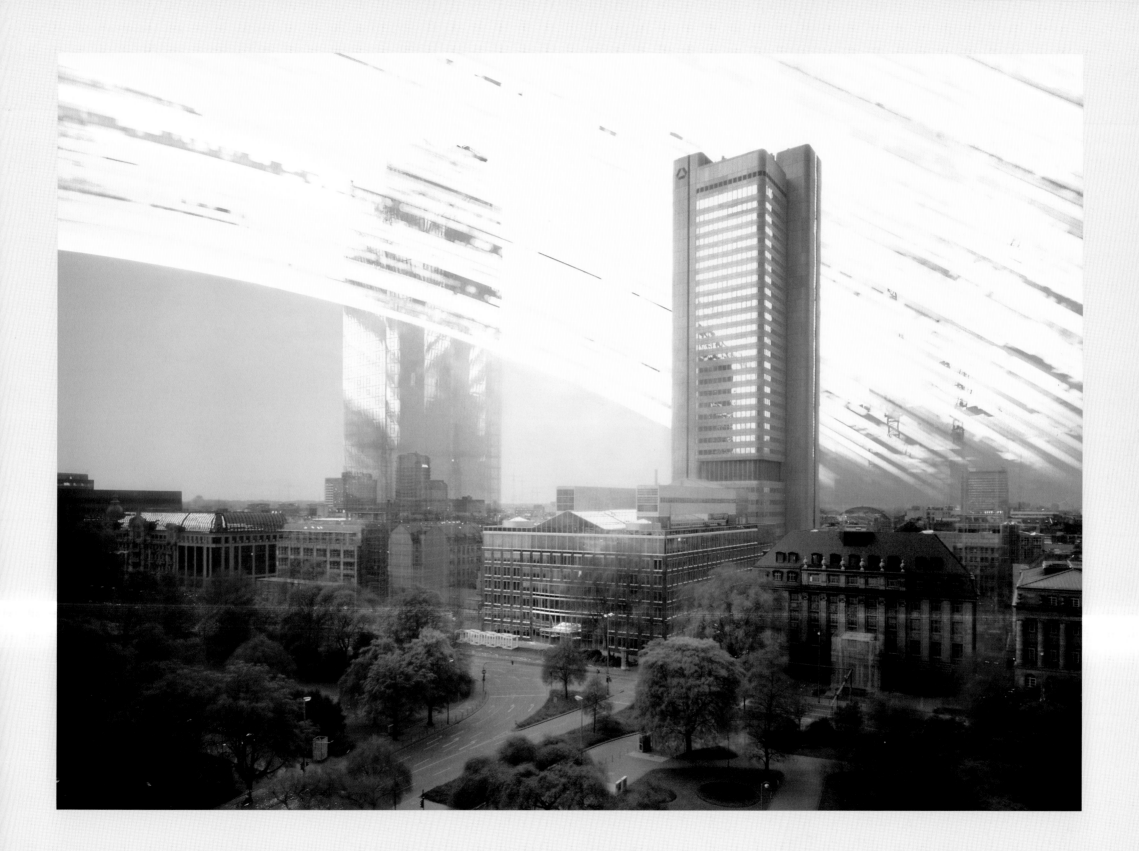

16.1.2001–4.4.2001
Abbau Infobox, Berlin

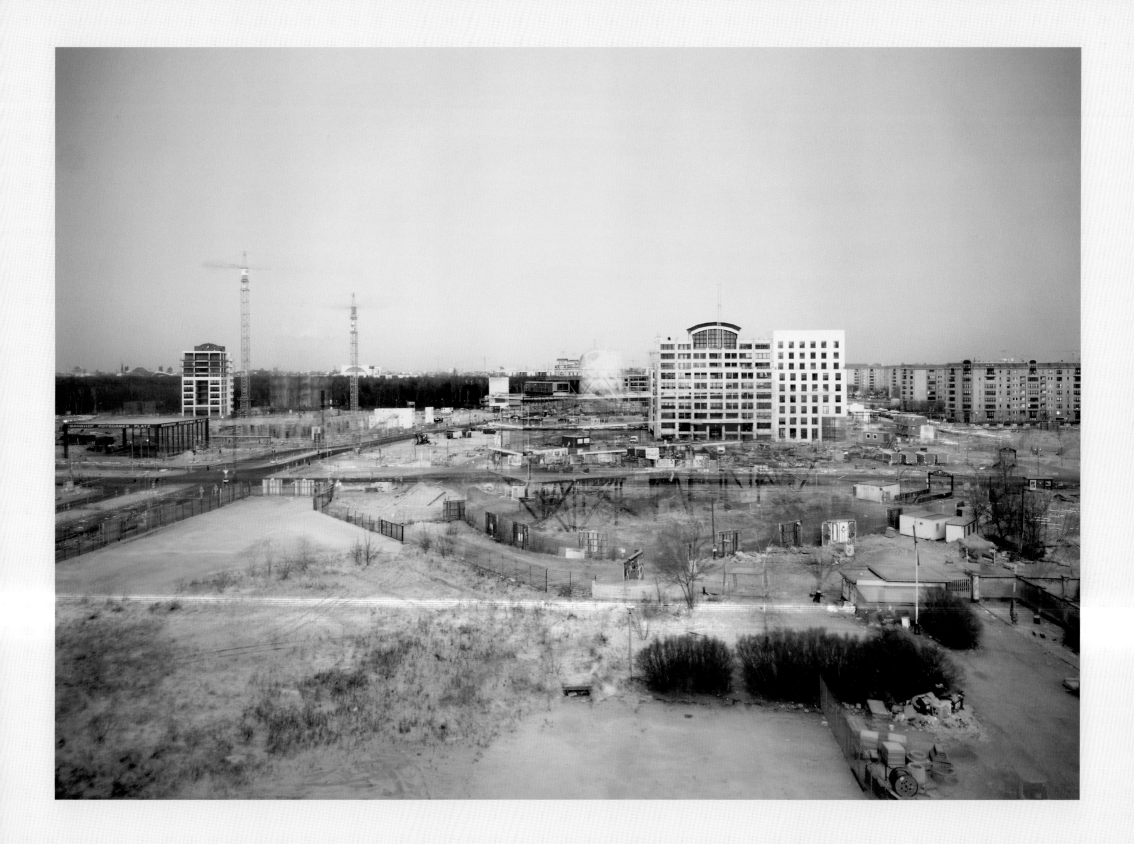

18.10.2002–18.10.2003
Central Park, New York

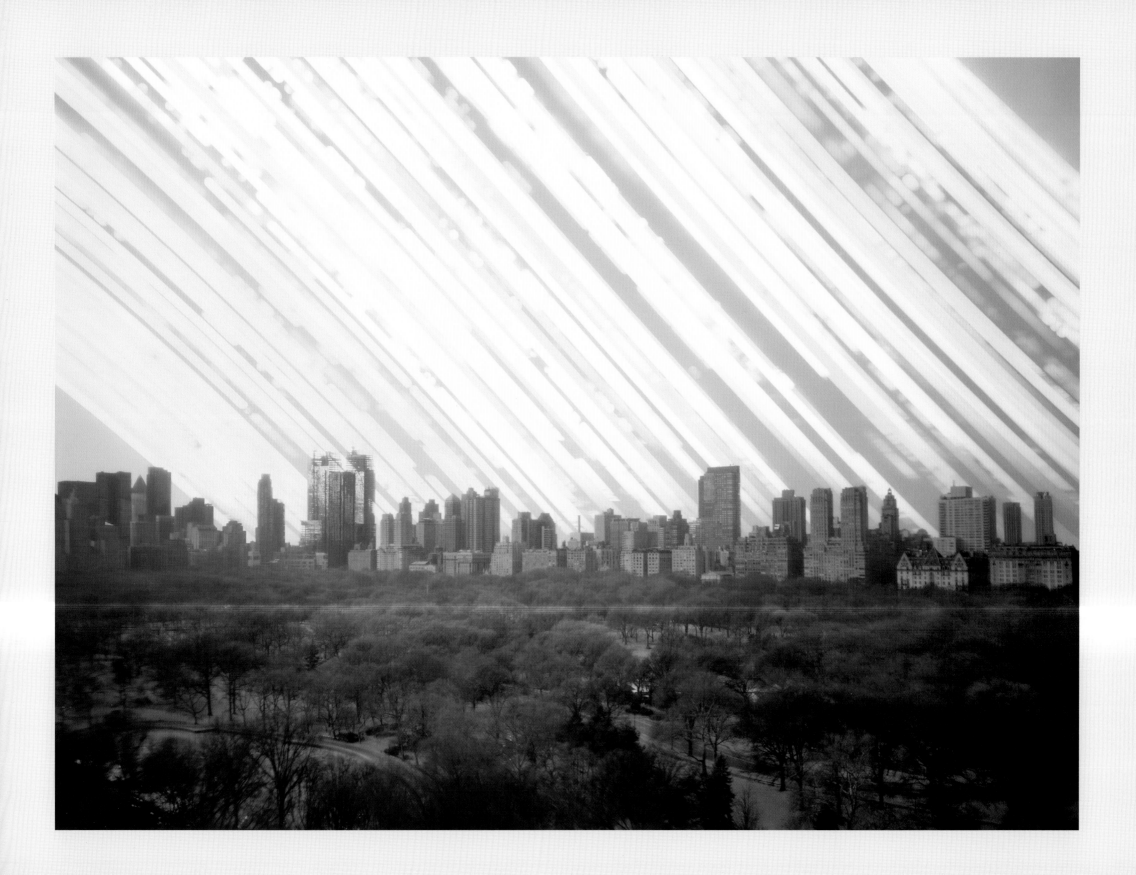

LIST OF PLATES

All black-and-white images were made from glass plate negatives measuring 5 x 7 inches. The color images were made from 5 x 7 inch transparencies, glued to aluminum plates to minimize their warping over the course of the exposure. All of Wesely's prints are chromogenic color prints that range from 31 ½ x 43 ⅜ in. (80 x 110 cm) to 6 ft. 6 ¼ in. x 9 ft. ¼ in. (200 x 275 cm). The dates that form part of the titles are listed in the European style: day, month, year. All of these prints are reproduced courtesy of the artist.

Open Shutter

15.6.2001–18.2.2003
The Museum of Modern Art, New York
The Museum of Modern Art, New York.
Purchase

9.8.2001–2.5.2003
The Museum of Modern Art, New York
The Museum of Modern Art, New York.
Purchase

9.8.2001–7.6.2004
The Museum of Modern Art, New York
The Museum of Modern Art, New York.
Purchase

7.8.2001–7.6.2004
The Museum of Modern Art, New York
The Museum of Modern Art, New York.
Purchase

7.8.2001–7.6.2004
The Museum of Modern Art, New York
The Museum of Modern Art, New York.
Purchase

Long Exposures, 1997–2003

19.3.1997–3.9.1997 Krefeld
Collection Paul Köser, Krefeld

27.3.1997–13.12.1998
Potsdamer Platz, Berlin
Collection DaimlerChrysler, Berlin

4.4.1997–4.6.1999
Potsdamer Platz, Berlin
The Museum of Modern Art, New York.
Gift of Howard Stein

5.4.1997–24.9.1998
Potsdamer Platz, Berlin
Collection DaimlerChrysler, Berlin

5.4.1997–3.6.1999
Potsdamer Platz, Berlin
Collection DaimlerChrysler, Berlin

8.1.1998–16.9.2002
Pinakothek der Moderne, Munich
Collection Michael Wesely

20.5.1998–18.5.1999
Pariser Platz, Berlin
Collection Thomas Kexel, Berlin, and
Collection Katharina Meinel, Berlin

9.4.1999–11.12.2000
Herrnstrasse, Munich
Collection Susi and Jochen Holy

14.4.1999–11.12.2000
Herrnstrasse, Munich
The Museum of Modern Art, New York.
Gift of Howard Stein

5.8.1999–6.12.2000
Leipziger Platz, Berlin
Collection Thomas Kexel, Berlin, and
Collection Katharina Meinel, Berlin

6.8.1999–6.12.2000
Leipziger Platz, Berlin
Collection Thomas Kexel, Berlin, and
Collection Katharina Meinel, Berlin

25.7.2000–3.6.2003
Dresdner Bank, Frankfurt
Collection Dresdner Bank, Frankfurt

16.1.2001–4.4.2001
Abbau Infobox, Berlin
Collection Michael Wesely

18.10.2002–18.10.2003
Central Park, New York
Collection Kara and Stephen Ross,
New York

BIOGRAPHY

Michael Wesely was born in Munich, Germany, in 1963. From 1986–88, he attended the Bavarian State School for Photography, and from 1988–1994 he attended the Academy of Fine Arts, both in Munich. He spent summer months in 1986, 1988, and 1990 at the Summer Academy for Fine Arts, Salzburg, Austria. In 1995, 1996, and 1999 he earned the DAAD (Deutscher Akademischer Austausch Dienst) Scholarship for study in the Netherlands, a scholarship from Kunstfonds e.V., Bonn, Germany, and the USA—Scholarship by the Bavarian State, respectively. Michael Wesely lives in Berlin.

EXHIBITION CHRONOLOGY

Selected One-Person Exhibitions

2003
Kleiner Ausflug, Kunstverein Rosenheim, Germany

Camera d'arte—ordine del giorno, Galica Arte Contemporanea, Milan

Iconografías Metropolitanas, Fahnemann Projekte, Berlin

2002
Metropolis: São Paulo, Goethe-Institut São Paulo (with Kalle Laar)

2001
American Landscape, Galerie Fahnemann, Berlin

2000
Paesaggi Americani, Galleria Primo Piano, Rome

La memoria dell' esposizione, Goethe-Institut Rome

American Landscape, Museum Schloss Moyland, Bedburg-Hau, Germany

Potsdamer Platz 1997–1999, Haus Huth, Berlin

1999
Photographien, Forum Kunst Rottweil, Germany

PHE99, Galería Metta, Madrid

1998
On Photography, Stefan Stux Gallery, New York

1997
Spiaggia, Galleria Primo Piano, Rome

Strand, Walter Storms Galerie, Munich

1996
Analytical Work, Museum voor Fotografie (now FotoMuseum Provincie), Antwerp

1995
New York 1995, Walter Storms Galerie, Munich

Palazzi di Roma, Galleria Primo Piano, Rome

1994
Camera Obscura, Neue Galerie Dachau, Germany

Reisezeit, Goethe-Institut Rotterdam

Selected Group Exhibitions

2004
Made in Berlin, Art Forum Berlin

2003
4ª Bienal do Mercosul, Porto Alegre, Brazil

Interrogare il luogo, Studio la Città, Verona

2002
A Cultura da Favela, Paço Imperial, Rio de Janeiro

XXV Bienal de São Paulo

Brasilia Ruine e Utopia, Centro Cultural Banco do Brasil, Brasilia

2001
2115 km: Current Art from Bavaria, Moscow Museum of Modern Art

2000
Seeing Double, MoMA2000: Making Choices, The Museum of Modern Art, New York

1999
El Retorno de Humboldt, Asociación Cultural Humboldt, Caracas

Wohin kein Auge reicht, Deichtorhallen Hamburg

1998
Es grünt so grün..., Bonner Kunstverein, Bonn

Die Macht des Alters—Strategien der Meisterschaft, Kronprinzenpalais, Berlin (traveled to Kunstmuseum Bonn and Galerie der Stadt Stuttgart)

1994
Züge Züge die Eisenbahn in der zeitgenössischen Kunst, Städtische Galerie Göppingen and Villa Merkel, Esslingen, Germany

SELECTED BIBLIOGRAPHY

Christofori, Ralf. *Potsdamer Platz*. Berlin: Sammlung DaimlerChrysler Haus Huth, 2000. In German and English.

Finkeldey, Bernd. *Michael Wesely*. Bedburg-Hau: Stiftung Museum Schloss Moyland, 2000. In German.

Friedel, Helmut. *American Landscape*. Munich: Walter Storms Verlag, 2000. In German and English.

——. *Reisezeit*. Rotterdam: Goethe-Institut Rotterdam, 1994. In German and English.

——. *Show up: Camera d'arte—ordine del giorno, Michael Wesely*. Milan: Galica Arte Contemporanea, 2003. In Italian and English.

Fuchs, Martina. *Michael Wesely: Photographien/Photographs*. Berlin: Galerie Fahnemann, 2001. In German and English.

——. *New York 1995*. Munich: Walter Storms Verlag, 1996. In German and English.

Schreiber, Kathinka. *Michael Wesely: Kleiner Ausflug*. Rosenheim, Germany: Kunstverein Rosenheim, 2003. In German.

Starl, Timm. *Michael Wesely: Camera Obscura*. Dachau: Neue Galerie Dachau, 1994. In German.

Van Cauteren, Philippe. *Ostdeutschland*. Cologne: Walter König Verlag, 2004. In German and English.